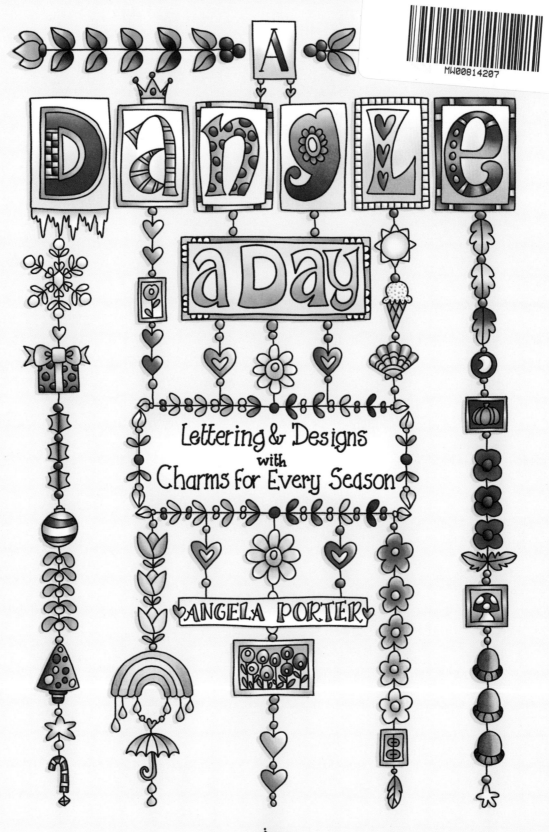

A Dangle a Day

a Day

Lettering & Designs
with
Charms for Every Season

ANGELA PORTER

Race Point
PUBLISHING

MW00814207

Brimming with creative inspiration, how-to projects, and useful information to enrich your everyday life, Quarto Knows is a favorite destination for those pursuing their interests and passions. Visit our site and dig deeper with our books into your area of interest: Quarto Creates, Quarto Cooks, Quarto Homes, Quarto Lives, Quarto Drives, Quarto Explores, Quarto Gifts, or Quarto Kids.

Text and Illustrations © 2019 by Angela Porter

First published in 2019 by Race Point,
an imprint of The Quarto Group,
142 West 36th Street, 4th Floor,
New York, NY 10018 USA

T (212) 779-4972 F (212) 779-6058
www.QuartoKnows.com

All rights reserved. No part of this book may be reproduced in any form without written permission of the copyright owners. All images in this book have been reproduced with the knowledge and prior consent of the artists concerned, and no responsibility is accepted by producer, publisher, or printer for any infringement of copyright or otherwise, arising from the contents of this publication. Every effort has been made to ensure that credits accurately comply with information supplied. We apologize for any inaccuracies that may have occurred and will resolve inaccurate or missing information in a subsequent reprinting of the book.

Race Point titles are also available at discount for retail, wholesale, promotional, and bulk purchase. For details, contact the Special Sales Manager by email at specialsales@quarto.com or by mail at The Quarto Group, Attn: Special Sales Manager, 401 Second Avenue North, Suite 310, Minneapolis, MN 55401, USA.

10 9 8 7 6 5 4 3 2 1

ISBN: 978-1-63106-569-9

Editorial Director: Rage Kindelsperger
Managing Editor: Erin Canning
Acquiring Editor: Melanie Madden
Cover Design: Quarto Publishing Group
Interior Design: Melissa Gerber

Printed in China

CONTENTS

Introduction

What Is a Dangle?

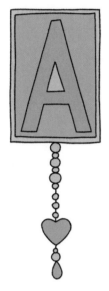

A dangle is a beautiful string of charms you can use to decorate all kinds of things, including alphabets, shapes, borders, illustrations, quotations, and anything else you can think of. They make perfect embellishments for bullet journals, planners, gift cards, and all kinds of stationery.

There are no rules to how you draw dangles; the only limits are those that you set yourself or that come from your creativity and imagination. However, the more you draw them, the more creative and imaginative they will become as your confidence increases. In the process, you will find that dangles are endlessly customizable, especially as you start to add your own charms and dangle designs to different lettering alphabets in your own custom directories.

Remember as you go through the mini-tutorials that these designs are only suggestions. You may—in fact, you are encouraged—to change and adapt them as you wish, creating finished works of art that are manifestations of your own personality, artistry, and imagination. Here's how I approach designing a dangle.

THE PROCESS

Even though the finished artwork may look complex, drawing dangles is really a fairly simple process. The examples in this book may look quite daunting, but really, they each take no more than six steps from blank page to a gloriously colorful dangle! Here's how I approach designing a dangle.

First, I decide on the theme and focal point of my design. Do I want to create a greeting for a specific person or a sentiment in a box or banner? Is this design going to be on a card, or am I using it to decorate my bullet journal? I also need to think about the medium I'm going to use to color the design, and what kind of paper is suitable for this medium.

Next, I use a pencil to sketch out my focal point. If it's not quite what I'm going for, I alter it until I am happy with how it looks. Then I decide how simple or ornate I would like the dangles to be, and where I'm going to attach them. Should I attach them with a simple line or a shape, such as a round bead, a diamond, or a leaf?

Now it's time to start drawing the dangles. I usually begin with a few guidelines in light pencil. If I want them to be asymmetrical, I might start on the left-hand side of the design. If I'm

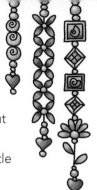

creating a symmetrical design, the center dangle is a logical place to begin. After sketching out the charms on the guidelines, I add spacer beads and short patterns between them. I also like to add hearts, feathers, raindrops, or other shapes to the end of the dangles to give them a little more "weight," much like a sparkly gemstone at the end of a dangly earring.

After you've sketched out your dangles, it's time to take a good look at the overall design to see if the elements and focal point are balanced. Use your eraser and make any needed adjustments until you are happy with your design.

Now it's time to ink it in. Take your time, and don't worry if your lines aren't perfectly straight; slight wobbles will add a whimsical and warm, human quality to your design.

DRAWING TIP

If you're heavy-handed with the pencil or eraser, or if (like me) you prefer to sketch on dot grid or square grid paper, try placing a clean sheet of paper over your design and, using a light box, trace the design onto the new sheet of paper. If you're into digital drawing, you can scan or photograph your sketch and open it in a sketching app or program, such as Autodesk SketchBook Pro and work on a new layer.

Your final task is to add color! Make the color as simple or as complex as you like, thinking about which colors will complement the focal point and help bring out its theme. There's plenty of inspiration for color schemes for all seasons in this book.

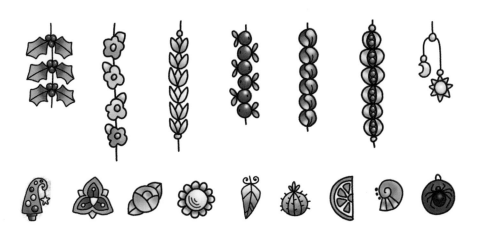

Recommended Materials

Here are some suggestions for materials you can use to create your designs. If you experiment with different media, you'll find one, or a selection, that gives you that results you're looking for.

GRAPHITE PENCIL AND ERASER

I always sketch out my ideas using a pencil of some kind. I prefer a softer lead (2B), which doesn't damage the paper and is easier to erase. I also prefer mechanical pencils to traditional pencils that require sharpening. Experiment and find out which works best for you.

As for erasers, my favorite is the Faber-Castell moldable artist's eraser. No dust or paper damage with this one!

DRAWING PENS

When inking my designs, I like to use a fine-point pen with waterproof pigment ink, ranging in size from 01 for fine details to 08 for bold lines. Sakura Pigma Micron, Sakura Pigma PN, Sakura Pigma Sensei 04, Uni-Ball Uni Pin, and Faber-Castell Pitt Artist all work great on any medium, or mixture of media.

WATERCOLOR MEDIA

If you're going to use water-based media, it is important to use watercolor or mixed-media paper. Some examples of white, smooth paper for mixed media include Daler-Rowney's Aquafine hot press paper, as well as the Clairefontaine and Canson brands. Consider testing out the following watercolor products:

- **Tim Holtz's Distress Inks from Ranger.** I press the ink pads on a sheet of plastic and use a damp brush to pick up the color. The inks are a little grungy and vintage-looking, which is appropriate for some projects.
- **Kuretake Zig Clean Color Real Brush Pens.** These bright, vivid colors can either be applied directly on paper or scribbled onto plastic and picked up with a damp brush.
- **Faber-Castell Pitt Artist Brush Pens.** These contain colored India ink. When wet, the color can be moved around with a damp brush or blended with a lighter color in the Pitt range. Once dry, the color is permanent.
- **Derwent's Inktense Pencils.** I lightly color in one part of the design and use a damp brush to gently activate and spread the pigment. With water applied, the color becomes much brighter. Sometimes I use a damp brush to lift the pigment directly from the tip of the pencil. Unlike Distress Inks and the Zig Clean Color pens, the Inktense pencil is permanent once dry.

As for watercolor brushes, make sure you have one with bristles that come to a sharp point when damp. I like Pro Arte Prolene Series 107 brushes in sizes 1, 2, and 4. A Zig Waterbrush from Kuretake is a good option as well.

Another useful watercolor product is Tim Holtz's Distress Micro Glaze from Ranger. The tiniest amount spread lightly on your finished, dry work will seal it, preventing any moisture from affecting the water-soluble pigments. It also gives a very slight sheen to your work.

ALCOHOL MARKERS

My favorite alcohol markers are the Chameleon pens, followed by Copics and ProMarkers. Colors can be blended, though it can take a little practice to learn how to do this. The markers are permanent, so it's a good idea to put some scrap paper beneath your work just in case the markers bleed through.

The bright white Winsor & Newton's Bristol board really makes the alcohol marker colors shine. Another good paper for alcohol markers is Neenah Solar White.

COLORED PENCILS

Crayola, Faber-Castell Art Grip, Faber-Castell Polychromos, Caran d'Ache Luminance, and Prismacolor are colored pencil brands that I use. More importantly, you need paper with a bit of "tooth." Mixed-media paper or heavy cartridge paper both work well with colored pencils. You can also get paper specifically designed for colored pencils or chalk pastels.

GEL PENS

White Sakura Gelly Roll, Uni Posca, and Uni-Ball Signo pens are great for adding small white dots as highlights or patterns to your design. Metallic and glitter pens from Sakura or Uni-Ball also add nice, sparkly, finishing touches.

OTHER EMBELLISHMENTS

I have a water container that reads, "My favorite color is glitter." And who doesn't love a little sparkle? In the world of crafting, there are lots of products you can use to make your dangles shine, including these:

- **Ranger Stickles or Liquid Pearls/Tonic Studio's Nuvo Crystal Drops.** The bottles have a fine nozzle on them, so with a little practice, you can control the size of the drop. They need to be left to dry for about an hour or so.
- **Self-adhesive gems and pearls.** Craft shops have loads of these.
- **Ranger Glossy Accents.** These can be used to give a raised, glassy effect.

Bullet Journals: A Primer

In the words of developer Ryan Carroll, "the bullet journal is a customizable and forgiving organization system. It can be your to-do list, sketchbook, notebook, and diary, but most likely it will be all of the above." Known in shorthand as "BuJo," this increasingly popular journal format allows people to easily create and endlessly customize any type of planner, tracker, diary, or scrapbook they need, often combining these different functions into one fun, dynamic, and highly illustrated chronicle.

There are a LOT of opportunities to be creative with bullet journals, but the following sections are among the most popular and most useful:

1. **Index.** Essentially a table of contents at the front of the journal that you use to skip to whichever sections you need.

2. **Future Log.** This is a snapshot of the coming year where you keep track of major events, tasks, or appointments.

3. **Monthly, Weekly, and Daily Calendars.** People often use their BuJos as customized planners, with each month featuring a different theme. Monthly calendars offer a snapshot of what lies ahead, while weeklies and dailies provide more space for creativity, tracking, and planning.

4. **Trackers.** These allow you to record the completion of or track different kinds of activities or even your day-to-day emotions. Examples of trackers include daily meditation, exercise, nutrition, sleep, mood, water intake, medication, cleaning, and income/expenditure. Need to track your commute time, screen time, or daily steps? You can do that, too! Track anything over a whole year, or monthly, weekly, or daily, depending on your needs.

5. **Lists.** Examples include to-do lists, goals, places visited, gratitude, favorite quotes, favorite songs, notable memories, books to read, ideas for blog posts, etc. Again, the possibilities are endless.

6. **Media Log.** A page or three at the back of the journal reserved for trying out new pens, pencils, and other media on the paper so you can see how they look and make sure they don't bleed through. It's also useful for helping pick out color schemes for different pages or sections of the journal.

For years I've kept a kind of BuJo without even realizing it. In my "zibladone," or commonplace book, I've built directories of favorite patterns, Zentangles, and designs for flowers, whimsical houses, shells, butterflies, and other things. Scattered throughout these directories are notes, ideas, thoughts, memories, many quotes, and lyrics. The bullet journal system showed me that I need not carry around a separate planner, as the zibladone and agenda pages can be creatively combined into one.

Pre-printed planners, which work for many people, are not as flexible as a BuJo. Their layout is set, the space given to the year/month/day calendars is fixed, and they are often decorated for you. With a BuJo, you decide which sections to include, how much space is given to each, which color

schemes you want to have, and how you would like to decorate the pages.

Of course, you don't have to set this up all at once; one of the beautiful things about BuJos is that you create as you go, changing up the style, color, and content as the mood strikes you. For example, a few days before the end of the current month you may come up with a design for the next month's calendar(s). Furthermore, BuJos provide plenty of opportunities to practice your hand lettering and drawing skills.

So, how do charms and dangles fit into all of this? In fact, they are perfect embellishments for titles, calendars, trackers, flowcharts, and lists of anything from quotes to birthdays. Dangles and charms are also great ways to fill up empty spaces or create separations between different rows or columns. Of course, dangle designs can be used in any journal, planner, diary, or notebook you prefer to use. Here are a few examples of how I use dangles and charms in my personal BuJo.

• PLANNER DANGLES •

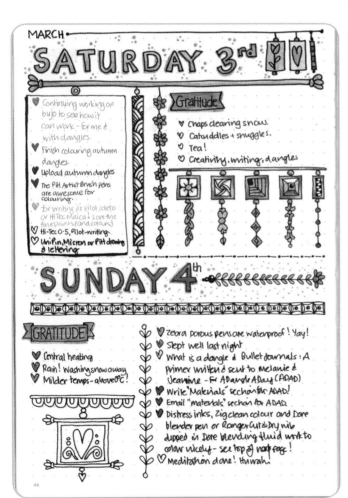

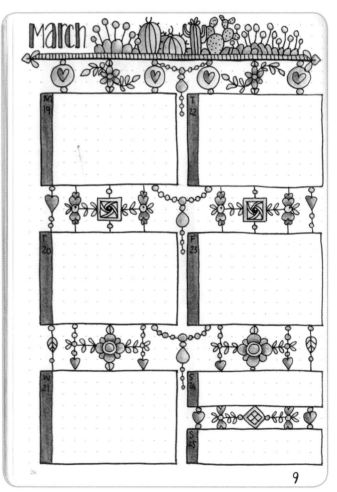

• "TRACKER" DANGLES •

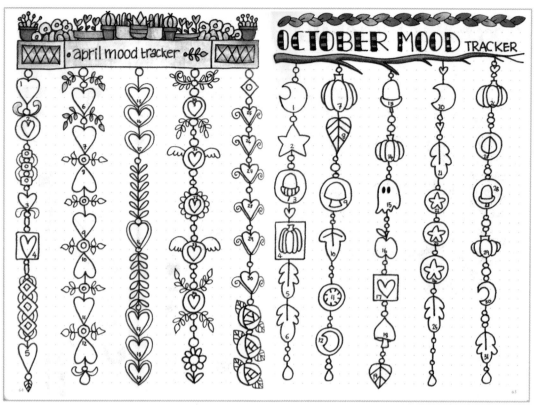

april mood tracker

OCTOBER MOOD TRACKER

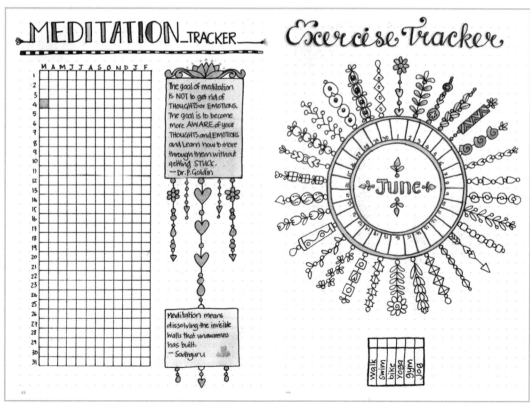

MEDITATION TRACKER

The goal of meditation is NOT to get rid of THOUGHTS or EMOTIONS. The goal is to become more AWARE of your THOUGHTS and EMOTIONS and learn how to move through them without getting STUCK.
— Dr. P. Goldin

Meditation means dissolving the invisible walls that unawareness has built.
— Sadhguru

Exercise Tracker

June

• "LIST" DANGLES •

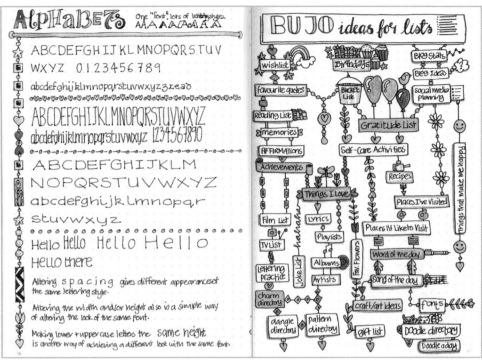

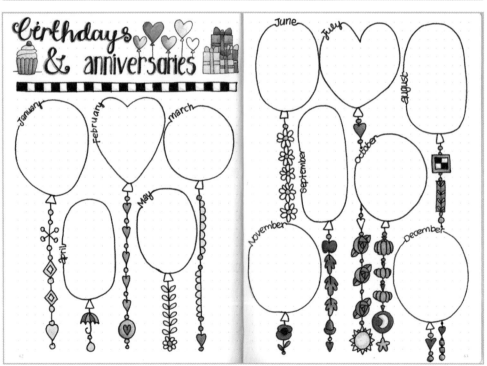

As with all art, it's important to come to terms with the fact that your BuJo (or your dangles, for that matter) will never be perfect or pristine; the designs will evolve as your needs change and your skills develop. There may be days when your hand lettering isn't the best or when you have chosen colors that clash. Embrace the imperfection as you develop your creative self.

Dangle Caps & Numerals

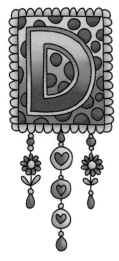

ecorative capital letters or initials have been used for centuries to add a special or divine quality to the beautiful illuminated manuscripts from the so-called Middle Ages onward. When the first printing press emerged in the 1450s, these decorations were retained in many books, and today we use similar, stylized "drop caps" for much the same purpose.

When journaling or when creating special greetings or uplifting designs, drop capitals make a heartfelt, hand-lettered quote or poem seem extra special. Add a dangle to the capital, and you have a lovely left-hand decorative border as well!

As shown on pages 50–53, dangle caps can also be used to stylize months, days, and other kinds of headers in a personal journal or scrapbook. They can also be used to create custom cards, tags, and gifts. Use these pretty capitals to create beautiful birthday, wedding, or holiday greetings, or use your friend's first initial in a personalized bookmark design!

Attaching dangles helps further personalize your designs and add thematic elements, as I did with my "spooky" October mood tracker. Pick colors that complement those of your capital letter, adding embellishments like metallic dots, white "shines," glitter, and sequins to really make them stand out.

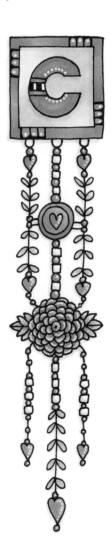

DANGLE DESIGN TIPS

- Always draw your design lightly in pencil first. The magic of the eraser will let you alter and refine your design before inking it in.

- Let the ink dry thoroughly before erasing the pencil lines. Always erase the pencil before coloring.

- Don't get discouraged! Hand-drawn work is perfectly imperfect, and color will bring it all to life.

1. Draw a simple block letter A.

2. Draw a double box around the letter.

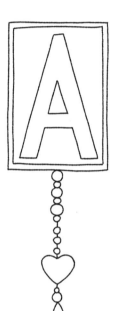

3. Add a dangle. For this one I used a simple combination of round beads, a heart, and finally a teardrop shape to add "weight" to the dangle.

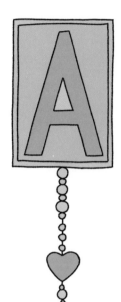

4. Add color. For a more cohesive look, choose three or four colors, using them both in the capital and the dangle.

 NOW IT'S YOUR TURN!

1. Draw a block letter B with a simple outline.

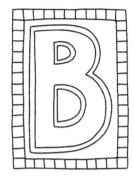

2. Draw a border around the B and divide it into squares.

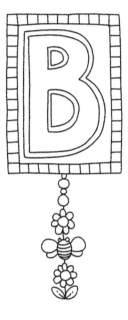

3. Add a dangle. It's no accident that I drew a bee charm for the letter B, and where you find bees, you find flowers!

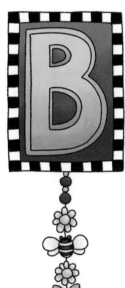

4. Add color. The black-and-white checkered border adds a very strong graphic element to the design. Blue/purple and orange/yellow are complementary colors (i.e., they are on opposite sides of the color wheel), so they make the other look brighter when placed next to each other.

 NOW IT'S YOUR TURN!

1. Draw a simple block letter C.

2. Add some polka dots. These can the same size or different sizes, arranged in a regular pattern or at random.

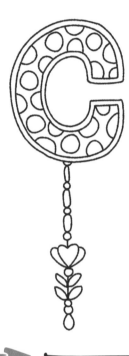

3. Add a dangle. For this one I used a simple combination of round beads, a heart, and finally a teardrop shape to add "weight" to the dangle.

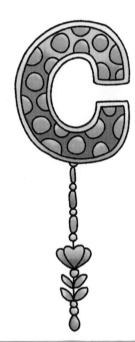

4. Add color. The blue, green, and yellow are analogous colors-that is, they are next to each other on the color wheel and work harmoniously together.

 NOW IT'S YOUR TURN!

1. Draw a block letter D with an outline.

2. Add a box around the D with half-circles for a scalloped, lacy look.

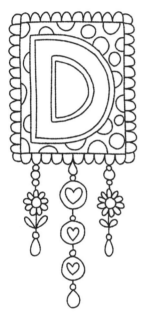

3. Add polka dots to the box, behind the D. Then add some dangles.

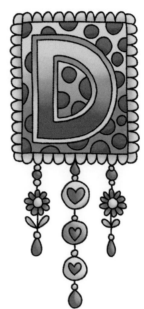

4. Add color! I used a really bright color scheme, with complementary colors that play against and enhance each other.

NOW IT'S YOUR TURN!

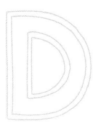

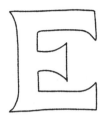

1. Draw a block letter E. Notice how the ends of the E curve outward in some places. These are called serif.

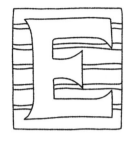

2. Draw a box around the E. Then add a striped pattern to it.

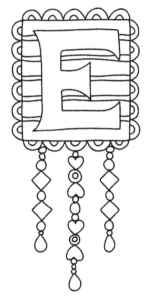

3. Add a semicircle pattern around the box. Then add some dangles.

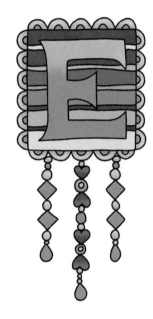

4. Add color! Red and green are complementary colors that make each other look brighter. Notice how the box gradient goes from dark red to a light pink for the wider lines and from light pink to dark red for the narrow lines. This adds some playfulness to the design.

 NOW IT'S YOUR TURN!

1. Switch it up! Draw a lowercase block letter F with an outline. Lowercase letters can make a word or message more informal, fun, and friendly when the mood strikes.

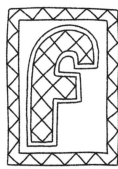

2. Add a harlequin pattern to your F. Then add a box with a zig zag border to match!

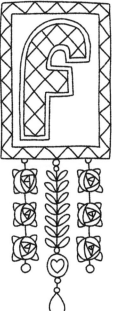

3. Add some dangles. Start with a circle for each rose and work inward to make sure they're all roughly the same size.

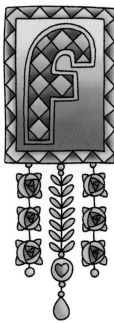

4. Add color! The hot pink and neon green make each other "pop."

NOW IT'S YOUR TURN!

1. Draw a simple block letter G with a simple rectangular frame.

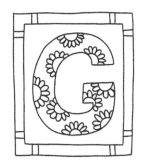

2. Draw a flower pattern inside the G.

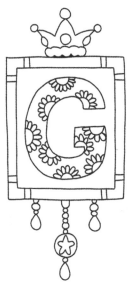

3. Add some simple dangles. Then top your design with a crown. Notice how the crown helps to vertically balance out your G design.

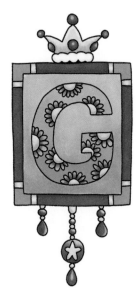

4. Color. This design really calls for some grand "jewel" colors—think ruby, emerald, and aquamarine—and, of course, gold!

NOW IT'S YOUR TURN!

20

1. Draw a block letter H with some elegance. Then frame it. The simple line patterns at the bottom left and top right of the frame help balance out the "flourishes" in the H.

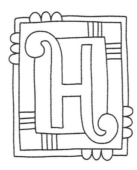

2. Add some semicircles to the upper left and lower right corners of the frame. Then add a third, thin frame behind them.

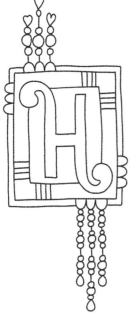

3. Attach dangles to the semicircles in Step 2. Dangles can shoot upward, too! Adding them on the upper left and bottom right helps balance the design vertically and from left to right.

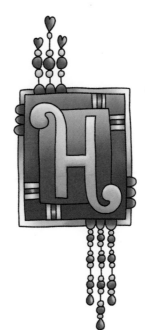

4. Add color. Rich, royal gold, blue, and red give a more masculine feel to this design.

NOW IT'S YOUR TURN!

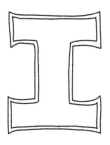

1. Draw a block letter I with a thin outline.

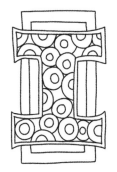

2. Fill the I with a circle pattern. Then draw a double-rectangle box behind it.

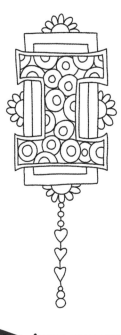

3. Add semicircles on each side of the box and add petals to them. Then hang a simple dangle from the bottom flower.

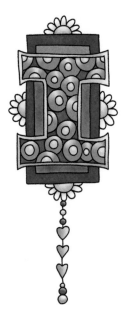

4. Color your design. Blue and purple are cool colors. Their complementary colors, yellow and orange, help lift and brighten the design.

 NOW IT'S YOUR TURN!

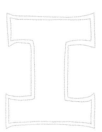

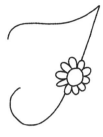

1. Start this design by drawing a simple daisy. Then, pencil in a curvy letter J.

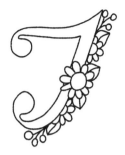

2. Make your J into a scripty block letter. Then add leaves, flowers, and berries along one edge of it. Who says all capitals must have boxy frames?

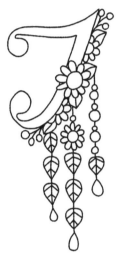

3. Hang some nature-themed dangles from a few evenly spaced leaves on your J design.

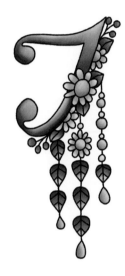

4. Add color. In this design, the aqua flowers practically sparkle against the rust and gold autumn leaves.

 NOW IT'S YOUR TURN!

1. Draw a block letter K. This one includes boxy serifs on the main vertical segment.

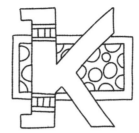

2. Embellish the vertical K segment with some simple bands. Then add a double rectangle behind the K. Fill the rectangle with circles.

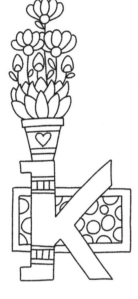

3. Draw an upward-growing dangle on top of the K: a pot of flowers! Start with the flowerpot. Add a couple rows of leaves before drawing the leafy stems and flowers.

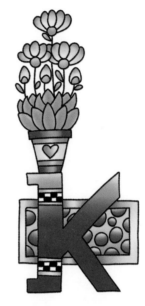

4. Add color. Bright, cheerful spring or summer colors make for a fun dangle design.

 NOW IT'S YOUR TURN!

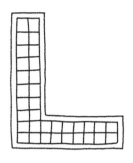

1. Draw a block letter L. Then outline it and fill it with a square grid.

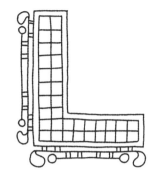

2. Add some decorative rods to the left and bottom sides of the L. Attach long rods with leafy ends before adding short rods with round ends.

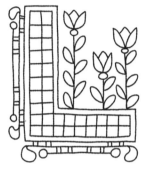

3. You can add upward-growing dangles here, too! Three flowers of varying height will do.

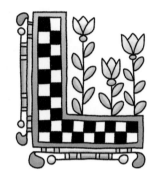

4. Add color. Sweet spring pastels soften the black-and-white checkerboard pattern.

 NOW IT'S YOUR TURN!

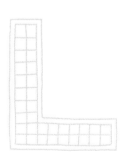

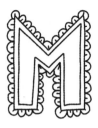

1. Draw a block letter M with a thin outline. Then add small semicircles around it.

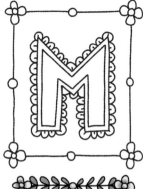

2. Pencil in a frame around the M. Draw small flowers at the corners and round beads at the centers of the sides of the frame.

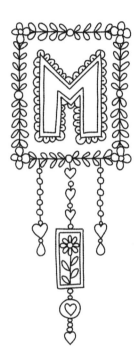

3. Add leaves to the frame and attach three dangles to the bottom vine.

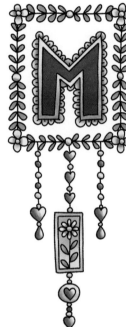

4. Color. Green and red/pink are complementary colors. They help make eachother look brighter.

 NOW IT'S YOUR TURN!

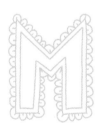

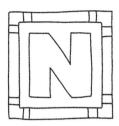

1. Draw a block letter N. Add a frame around it with bands near the corners the frame.

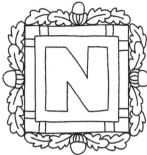

2. Draw an acorn in the center of each side of the frame. Add two leaves on either side of each acorn, extending the pattern to the edges of the frame.

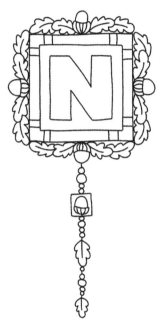

3. Hang an autumn-inspired dangle from the bottom-facing acorn.

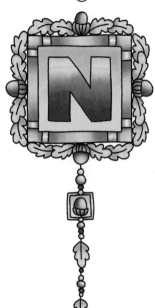

4. Add color. An autumnal color scheme suits this design.

NOW IT'S YOUR TURN!

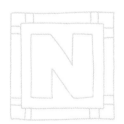

1. Draw a block letter O with a narrow hole inside of it.

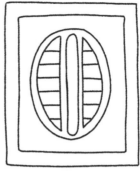

2. Add two lined sections inside the O. Then draw a frame around the O.

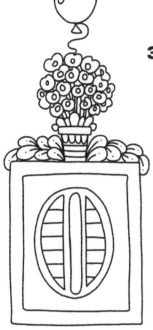

3. Add an upward-growing flowerpot dangle that culminates in a heart-shaped balloon. Adding leaves around the base of the pot softens the design.

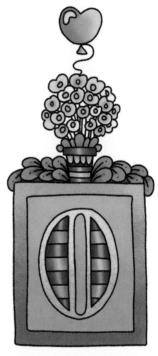

4. Add color.

NOW IT'S YOUR TURN!

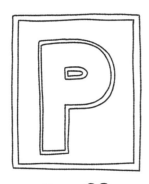

1. Draw an outlined block letter P. Add a thin frame around it.

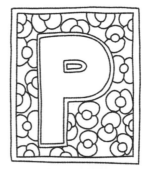

2. Fill the box between the letter and the frame with stylized poppies.

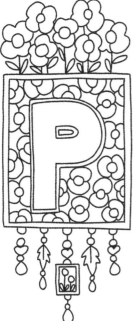

3. Grow some poppy plants with leafy stems from the top of the box. Also add some simple dangles below to balance it all out.

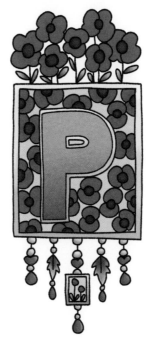

4. Add color.

 NOW IT'S YOUR TURN!

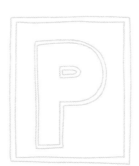

29

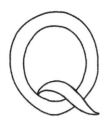

1. Draw a block letter Q. Notice how the tail of the Q has been drawn to look like it is lying over the ring of the Q.

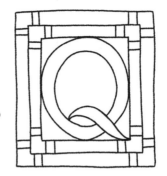

2. Draw a series of three boxes around the Q, with the smallest one touching the letter on all four sides. Add a few decorative bands to the corners of the two resulting frames.

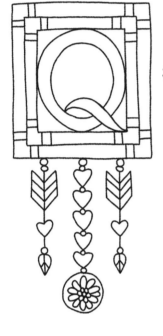

3. Add dangles. I decided to flank the central one with some stylized arrows.

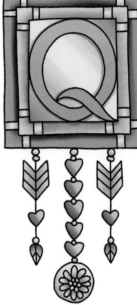

4. Add color. Notice how using a color gradient effect on the hearts makes them look almost 3-D!

NOW IT'S YOUR TURN!

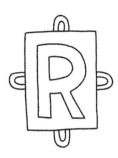

1. Draw a block letter R. Then draw a box around it and add some loops to the centers of each side.

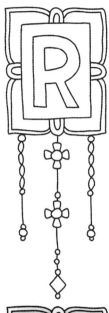

2. Add squarish petals between the loops and sketch a simple foundation for three dangles.

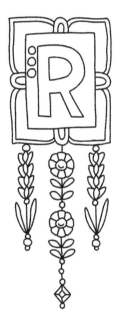

3. Complete the dangles, creating lovely floral charms to tie in with the petals around the R. Add a trio of circles to the left of the R as an added embellishment.

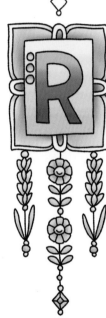

4. Add color. Lilac, gold, and green give this design a very summery feel!

NOW IT'S YOUR TURN!

1. Start with a stylized block letter S. Add some fun patterns inside it. Then add two circles that nestle inside the curved ends of the S.

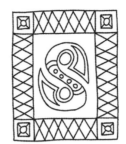

2. Draw a fat frame around the S, with squares at the corners and a funky diamond pattern between them. Draw square jewels in each corner.

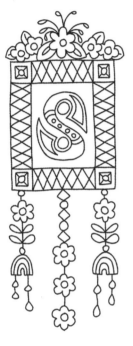

3. Draw a flower on top of the frame, with leaves and smaller flowers on either side. Next, attach dangles to the bottom of the frame. Rainbows and raindrops give your design a springy feel. Also, notice how the spidery stamen-like growths behind the large flower give the top garland more height.

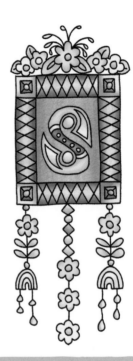

4. Add color. I chose a pastel color scheme for the flowers and dangles, contrasting with a bright orange, red, and blue capital.

NOW IT'S YOUR TURN!

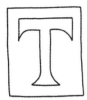

1. Draw a block letter serif T inside a box.

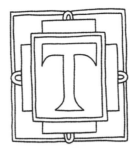

2. Add an outline to the box. Then draw rectangles along each edge of this outline, adding loops to the centers of each one. Finally, draw the outer frame, making sure to run it under the loops.

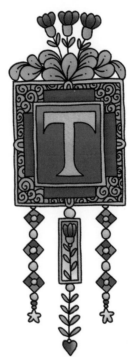

3. Add leaves and some stylized tulips above the frame. Then add some dangles. Fill the space between the inner frames and the outer frame with a small spiral pattern.

4. Add color. Rich sapphire, ruby, emerald, and gold give a sense of luxury to this design.

NOW IT'S YOUR TURN!

1. Draw n block letter U with a thin outline. Then frame it.

2. Add semicircular scallops around the frame, and fill the inner box with a concentric circle pattern.

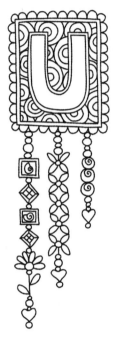

3. Attach three dangles to the bottom of the frame. In this design, they get shorter from left to right, and spiral shells add a unique element.

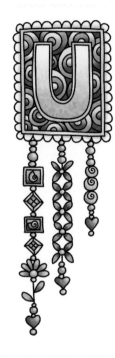

4. Add color. Lots of bright colors give this design a fun, funky, and cheerful feel.

NOW IT'S YOUR TURN!

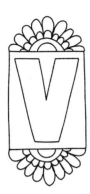

1. Draw a block letter V in a box. Then add half-flower designs to the top and bottom of the box. For each flower, start by drawing two semicircles. Add a row of small semicircular petals, followed by a final row of larger petals.

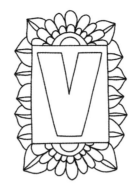

2. Add leaves to both sides of each flower. Then add leaves down the sides of the box.

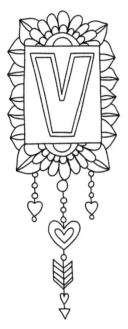

3. Add three simple dangles to the bottom of the design. To make the V stand out more, add an outline inside of it.

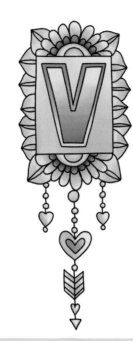

4. Add color. Soft violet-pink, sea-green, and periwinkle make a lovely, calm trio.

NOW IT'S YOUR TURN!

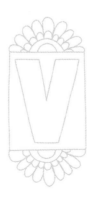

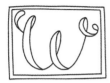

1. Try your hand at a scripty W inside a double-outline box. Notice now the left-hand loop falls behind the W, while the right-hand loop falls in front.

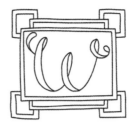

2. Add a taller, thinner frame behind the box. Then add double squares to the corners, layered behind both frames.

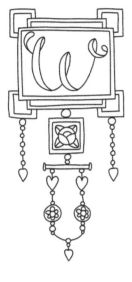

3. Hang a thick dangle with a square charm from the center of the design, with two small dangles on either side. Notice how the attachment of a bar to a large charm supports two dangles that are joined together at the end by an elegant loop with a small heart charm.

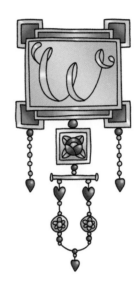

4. Color! I went with a springtime color theme for this one.

 NOW IT'S YOUR TURN!

1. Draw a simple outlined block letter X.

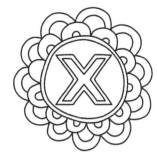

2. Draw a double circle around the X. Then draw two layers of semicircular scallop petals around the circle.

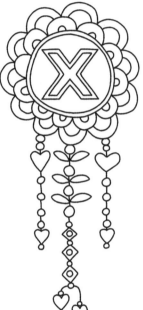

3. Add some dangles. Notice the branching charms on the end of the center dangle.

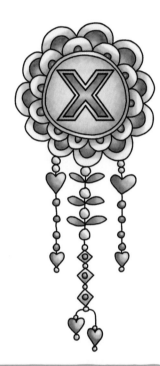

4. Add color. The use of blues and complementary colors around the x helps it stand out.

NOW IT'S YOUR TURN!

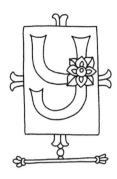

1. Start by drawing a small flower. Make this the fork of your curly Y design. Draw a box around the letter and attach little foliage designs in the center of each side.

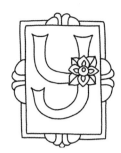

2. Add curves on both sides of each foliage design. Then draw a frame that connects them.

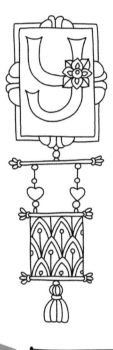

3. Add a couple of dangles to the decorative rod with which to hang a large square charm with decorative rods above and below it. Add a pattern to the large square charm. This design calls for a luxurious pattern. Add a tassel to the charm at the bottom to make the design extra-luxurious.

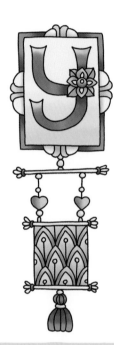

4. Add color.

NOW IT'S YOUR TURN!

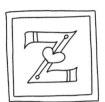

1. Draw a block letter Z with serifs. Add a heart to the center of the Z, with lines extending away from it along the letter's diagonal. Add decorative bands to the ends of the Z and add a frame around the design.

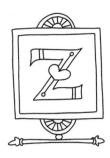

2. Add patterned semicircles at the top and the bottom of the box. Attach a decorative rod to the bottom one.

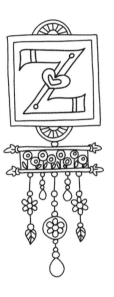

3. Leave a gap and then draw another decorative rod, with three simple dangles attached. Draw stylized flowers between the two rods and connect the rods to each other.

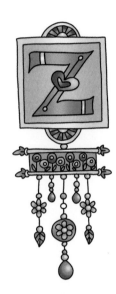

4. Add color.

NOW IT'S YOUR TURN!

1. Draw a block number zero. Add a vintage label box behind it.

2. Add an outline to the label box. On the top of the zero, add a crown.

3. Draw some fun patterns inside the zero. Then add a dangle.

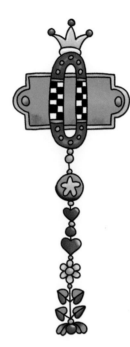

4. Add color.

 NOW IT'S YOUR TURN!

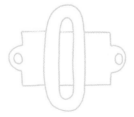

40

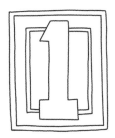

1. Draw a block number 1 with a doubleframe behind it.

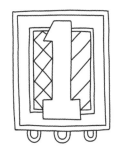

2. Add a diamond pattern to the central box. Then add three loops at the bottom of the box.

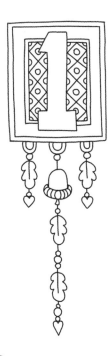

3. Add circles to the center of each diamond behind the 1. Then add the dangles.

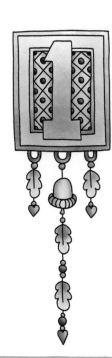

4. Add color. The soft pink and green give the design a vintage look, and I've used shadows and highlights to add dimension.

 NOW IT'S YOUR TURN!

1. Draw a block number 2 with a simple frame.

2. Draw a flower with leaves on the 2. Then draw some flowers on top of the box.

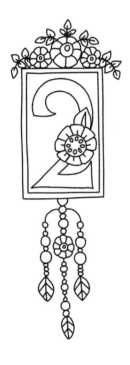

3. Add some leafy vines to the flowers at the top of the design. Add a simple dangle below it with two more dangles sprouting from the first one.

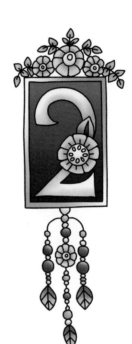

4. Color! Notice how using the same kind of flower design results in a coherent design.

NOW IT'S YOUR TURN!

1. Draw a block number 3 with a simple frame.

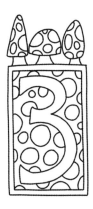

2. Add circles to the inner box. Then draw three fairy toadstools on top of it.

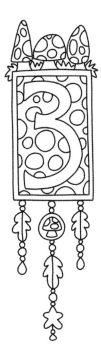

3. Add three dangles to the bottom of the design.

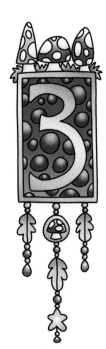

4. Color. Including a red-and-white fairy toadstool above and below the box creates cohesion.

 NOW IT'S YOUR TURN!

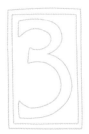

1. Draw a block number 4.

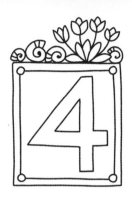

2. Draw a basic frame around the 4, with small circles at each corner. On the top of the frame, add some flowers, leaves, and shells.

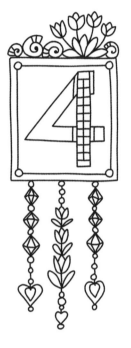

3. Add three dangles below the frame. Then add a funky checkerboard pattern with borders inside the 4. Notice how the flowers on top of the design appear again as charms.

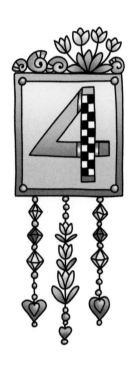

4. Add color. The yellow tulips add a bit of cohesion to this design.

NOW IT'S YOUR TURN!

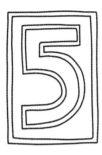

1. Draw an outlined block number 5. Then draw an outlined box around the 5.

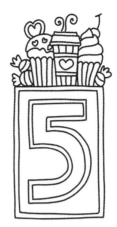

2. Draw a sweet arrangement of cupcakes, candies, and coffee on top of the box.

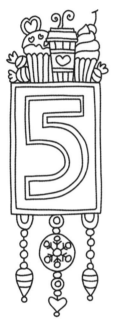

3. Attach three short dangles to the bottom of the box. Snowflake and bauble charms give this design a wintry theme.

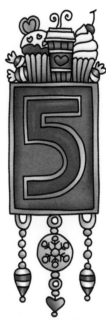

4. Add color. Red, green, and gold are a classic color combination for Christmas.

NOW IT'S YOUR TURN!

1. Draw a bubble number 6 with a simple frame around it.

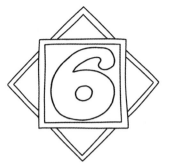

2. Draw a diamond frame behind the first frame.

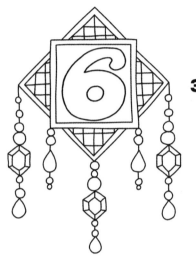

3. Add a checkerboard pattern inside the diamond-shaped frame and attach dangles to the bottom corners of both frames. Notice the unique six-sided, hexagonal crystal charms.

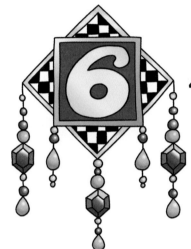

4. Add color. The black-and-white tiles add some graphic contrast to this design.

 NOW IT'S YOUR TURN!

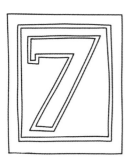

1. Draw an outlined block number 7. Then add three boxes around it, leaving a wider gap between the middle and outer box.

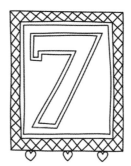

2. Fill the space between the middle and outer boxes with a diamond crisscross pattern. Then add three small hearts to the bottom of the outer box.

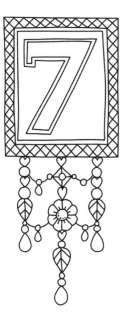

3. Attach dangles to the hearts. Then join the dangles to one another with some loops with teardrop beads. Seven hearts have been used in the design. Notice that there are also seven teardrop beads.

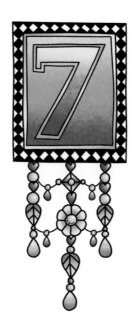

4. Add color. The blue gradient behind the 7 really makes this design pop!

NOW IT'S YOUR TURN!

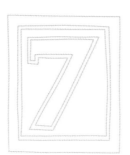

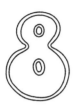

1. Draw an outlined bubble number 8.

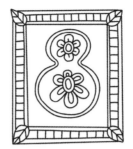

2. Draw a thick frame around the 8, consisting of four nested outline boxes and a large gap between the second and third ones. Fill this gap with evenly spaced lines. Then place leaves at the corners of the boxes. Finally, turn the circles inside the 8 into flowers.

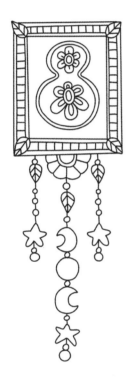

3. Add a semicircular flower motif at the bottom of the box. Then add some dangles. The 8 shape resembles the infinity symbol, so I added moon charms to evoke the continuous cycle of moon phases.

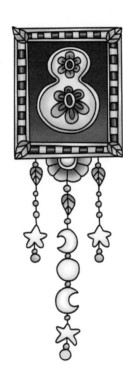

4. Color. Midnight blue, pearly blue-gray, soft yellow, sea green, and lavender make this design extra dreamy.

 NOW IT'S YOUR TURN!

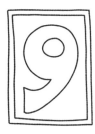

1. Draw a block number 9 with a simple frame around it.

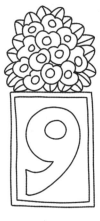

2. Draw a flower bush on top of the frame.

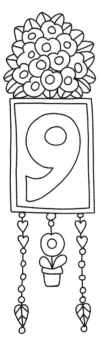

3. Add a trio of dangles below the frame. Notice how the flower charm in the middle dangle is the same kind of flower as those in the flower bush.

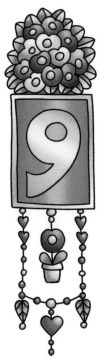

4. Use a curved chain of beads to connect the two outer dangles. Then add a short dangle to the center of this bead chain. Finally, add color!

NOW IT'S YOUR TURN!

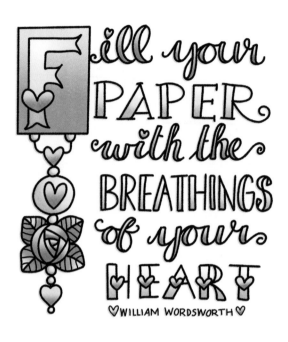

Fill your PAPER with the BREATHINGS of your HEART

♡ WILLIAM WORDSWORTH ♡

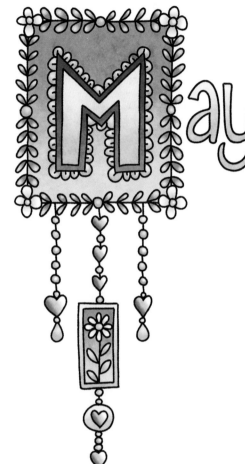

May

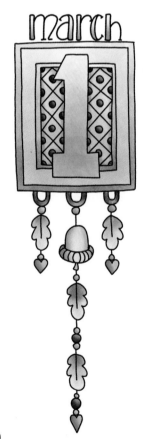

march

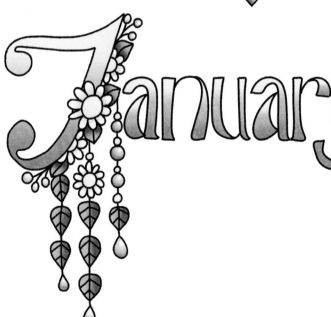

January

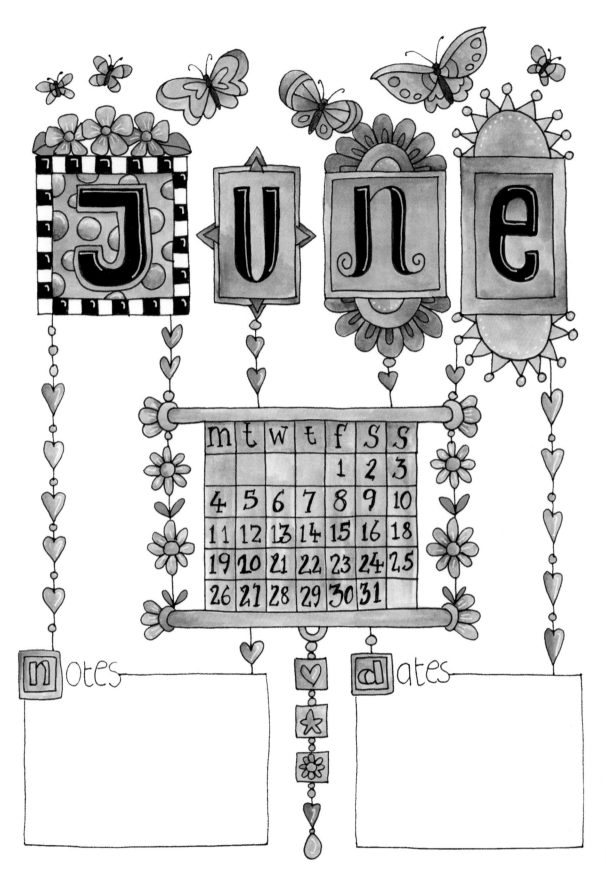

JUNE

m	t	w	t	f	s	s
				1	2	3
4	5	6	7	8	9	10
11	12	13	14	15	16	18
19	20	21	22	23	24	25
26	27	28	29	30	31	

notes

dates

Friday

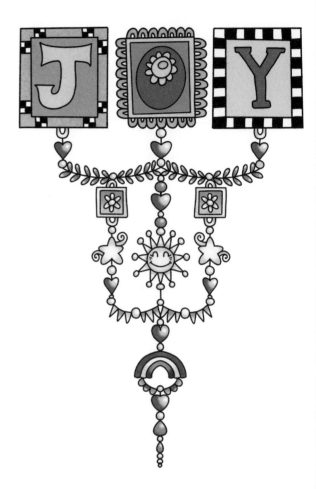

JOY

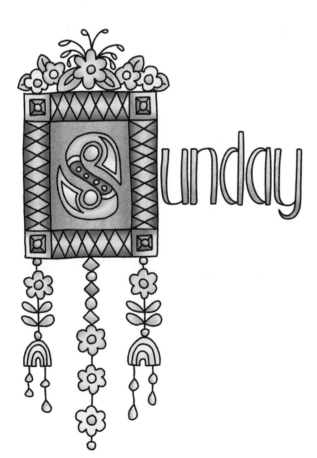

Sunday

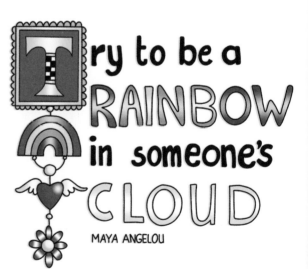

Try to be a RAINBOW in someone's CLOUD

MAYA ANGELOU

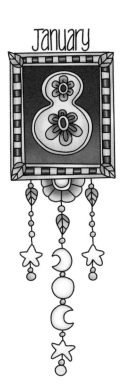

January

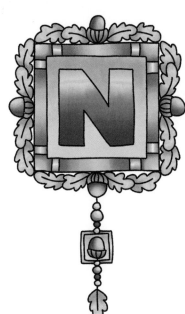

November

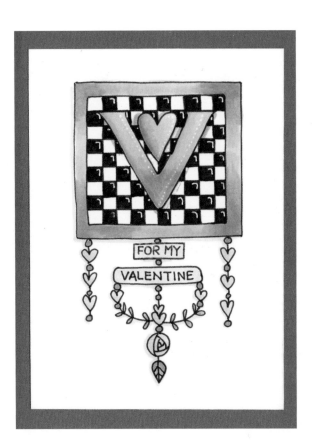

FOR MY

VALENTINE

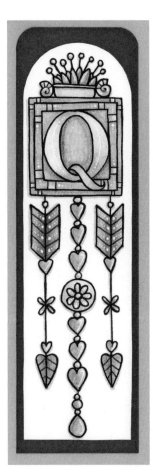

Dangle Designs for Every Season

n this section, we'll explore dangly seasonal designs you can use to decorate anything, from gift tags to greeting cards to scrapbooks. Although the finished designs may look complicated, I'll take you through all the simple steps. In the process, I'm sure you will find they are much easier to create than you think!

Feel free to mimic these designs or simply use parts of them to create your own projects. Dangles and charms can be modified in any way you like to suit your own needs and preferences. Try out different lettering styles and colors—just have fun with it all.

Note that different color palettes can be used to convey different seasons, occasions, and emotions. Below are some common schemes for winter, spring, summer, and autumn:

- **Winter:** Cool snowy blues, pearly grays, and white; Christmas reds, greens, gold, and silver; Hanukkah blues and golds; Valentine pinks and purples.
- **Spring:** Soft pastel rainbow colors; fresh yellow-greens; floral pinks, purples, and reds.
- **Summer:** Bright rainbow colors and deeper greens; beachy tropical golds, blue-greens, and coral.
- **Autumn:** Warm colors like amber and gold; earthy browns and greens; Halloween orange, black, lime green, and purple.

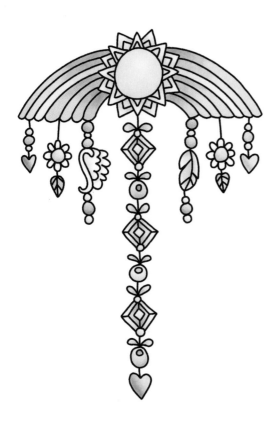

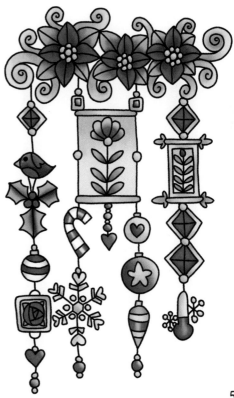

Winter

Snow, warm hats, cozy socks, hot drinks, Christmas trees, ornaments, fairy lights, celebrations, friends and family, and holly and ivy are just a few of the things that come to mind when I think of the winter months of December, January, and February. The dangle designs in this section incorporate these symbols of winter, along with Hanukkah candles and Valentine's Day hearts. Below are a few winter-themed dangles and charms:

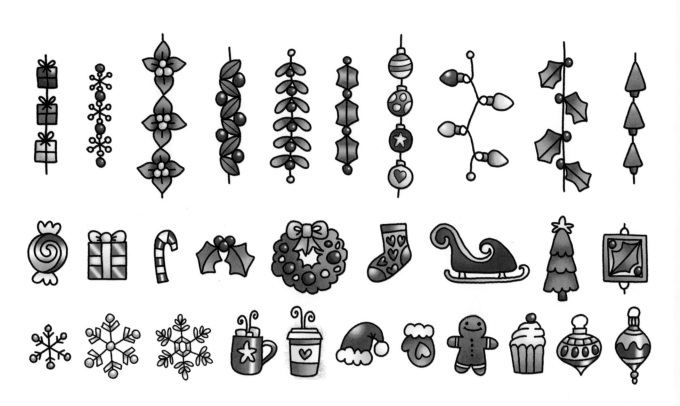

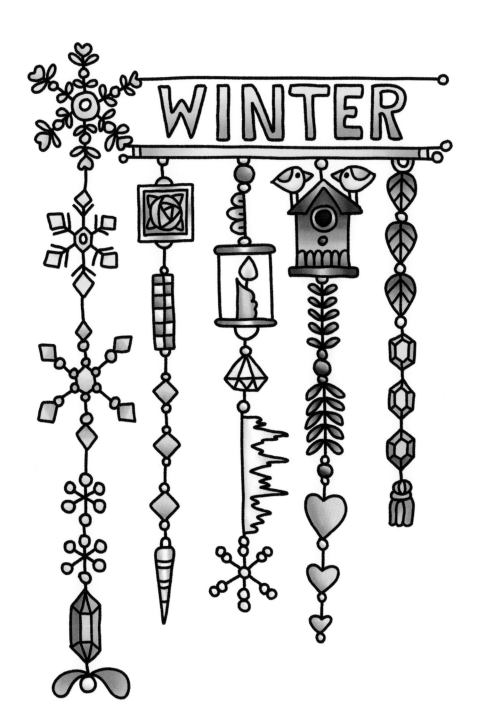

1. Write "December" in a fun and festive font. Add a rectangular border around it.

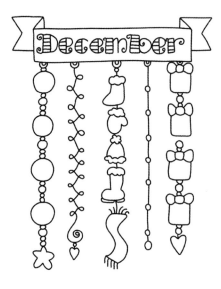

2. Make your border into a ribbon-style frame. Then add five equally spaced dangle designs. The round ornaments and present-shaped charms evoke Christmas, and the wintry clothing charms are very appropriate for this design!

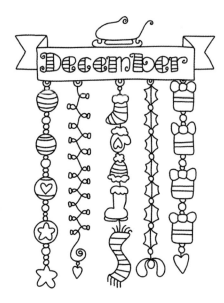

3. Add patterns and additional wintry and Christmas details to your dangles. Begin sketching a sleigh on top of your frame. Christmas string lights and holly make this design even more festive.

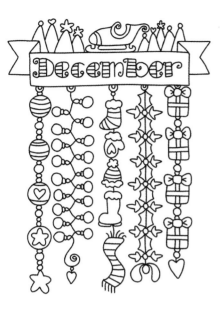

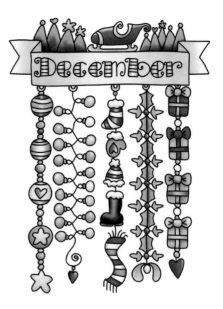

4. Add finishing touches to your sleigh and dangles. Adding Christmas trees on either side of the sleigh creates an overall balanced look.

5. Add color.

 NOW IT'S YOUR TURN!

1. Hand letter "Happy Hanukkah" and add a simple rectangular border.

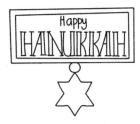

2. Draw nine evenly spaced candles about 2 inches (5 cm) above the rectangular box. Make the center candle (the shamash, "helper candle," taller than the four candles on each side of it.. Add a large Star of David-shaped charm below it.

3. Expand the first charm into a dangle. Start to add charms on either side of it.

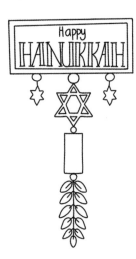

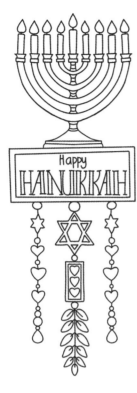

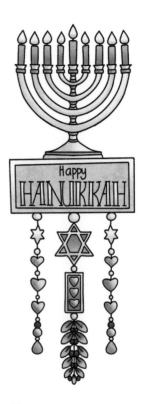

4. Sketch the menorah and add more charms and details to the dangles.

5. Add color. Blue and yellow-gold are an appropriate combination for this festive Jewish holiday.

NOW IT'S YOUR TURN!

Christmas

1. Hand letter "Christmas" in block letters. Add a small circle on the "C" as decoration.

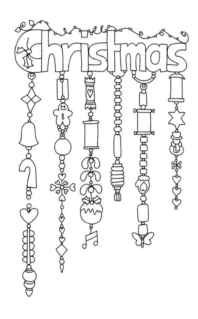

2. Add holly leaves to the small circle and draw the beginnings of wiggly string lights resting on top of the letters. Then hang six equally spaced dangles below, including charm outlines.

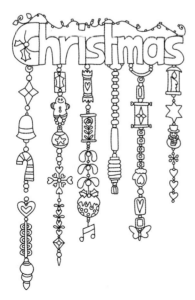

3. Fill in the details of your Christmas charms.

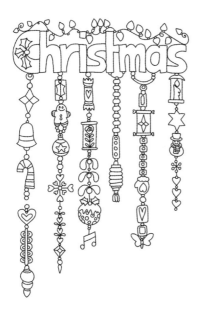

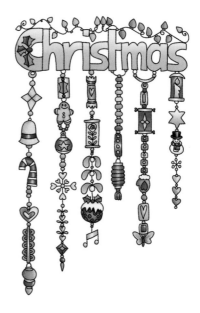

4. Add bulbs to your string of lights.

5. Add color. Using metallic pens or paints to add highlights would add a wonderful shimmer and shine.

NOW IT'S YOUR TURN!

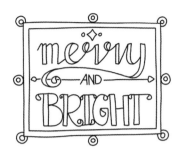

1. Hand letter "Merry and Bright" and add a simple frame around it. Then add circles at the corners and in the center of the sides. Notice a few simple design elements-coupled with a small, plain "and,"-help unite and balance out the overall design.

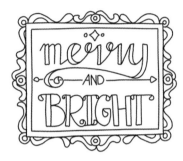

2. Add a few fancy swirls around the frame.

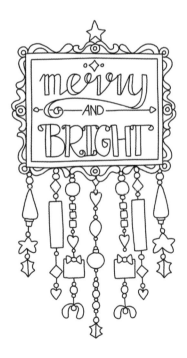

3. Add a star on top of the frame and hang several dangles below it. I kept the dangles symmetrical and close together, so the framed sentiment remains the focal point.

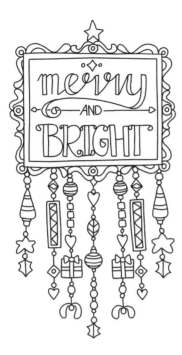

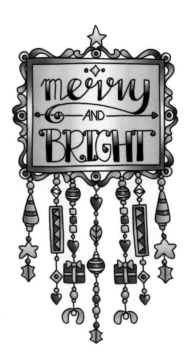

4. Fill in the details of your festive charms.

5. Add color. I used only four colors, so this design is very cohesive.

 NOW IT'S YOUR TURN!

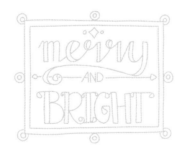

1. Hand letter "January" in a curly font and create a simple banner design around it.

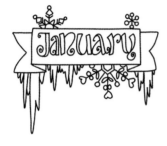

2. Add a few snowflakes randomly along the banner. Add some icicles along the bottom of it. Drawing half-snowflakes makes them look like they are tucked behind the banner.

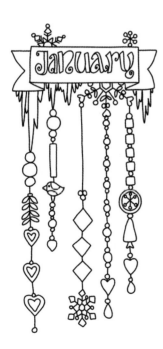

3. Anchor some dangles to the icicles, sketching in the outlines for the charms.

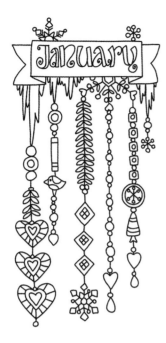

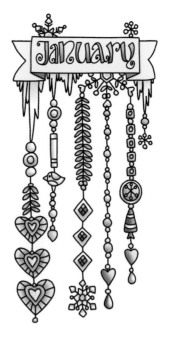

4. Add details to the charms.

5. Use wintry colors to complete the design. Glitter brush pens like Zig Wink of Stella or Spectrum Noir Sparkle would add a very fitting icy, glittery look.

NOW IT'S YOUR TURN!

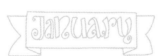

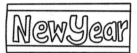

1. Hand letter "Happy New Year" and draw a simple box around it, with borders on the top and bottom.

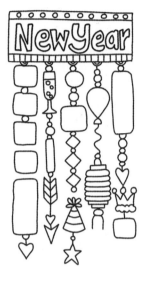

2. Draw evenly spaced circles in the top border and stripes in the bottom border. Then hang five evenly spaced dangles below it, with the basic outlines for charms.

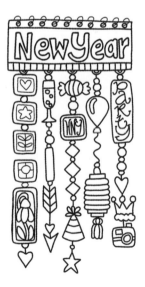

3. Add detail to the charms.

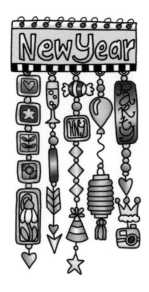

4. Add color. Bright, bold colors with metallic elements give the design a celebratory feel.

 NOW IT'S YOUR TURN!

1. Write "February" in block letters. Make the frame around it curl like a scroll on the right-hand side. Then attach five beads to the bottom of it.

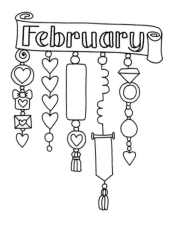

2. Add another scroll design to the left-hand side of the banner. Begin sketching in the dangles below.

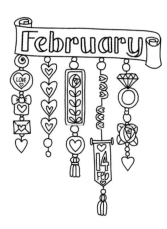

3. Add finishing touches to the scroll banner and charms.

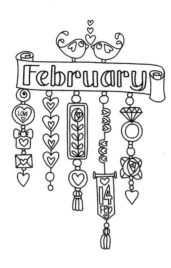

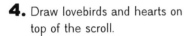

4. Draw lovebirds and hearts on top of the scroll.

5. Add color.

NOW IT'S YOUR TURN!

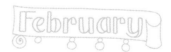

1. Write "Be My" in block letters and add a rectangle around it. Write "Valentine" in smaller letters below the box, adding a smaller rectangular frame around it. Connect the two boxes together.

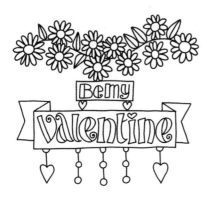

2. Add patterns to the block letters. Turn the bigger box into a ribbon banner. Draw a curvy flower garland above it, and then add the beginnings of five dangles below it.

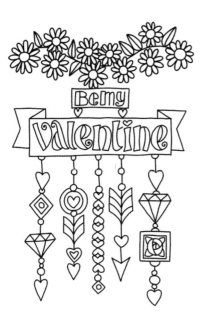

3. Finish your dangles with charms that reflect the themes of love and Valentine's Day.

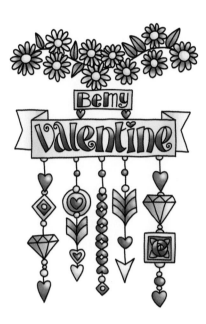

4. Add color.

NOW IT'S YOUR TURN!

Spring

As the days grow longer and warmer, flowers begin to bloom and fresh green leaves start to show themselves. When I think of spring, I always think of uplifting, soft rainbow colors, April showers, sunshine, Easter eggs, and lots and lots of flowers! Below are a few spring-themed dangles and charms:

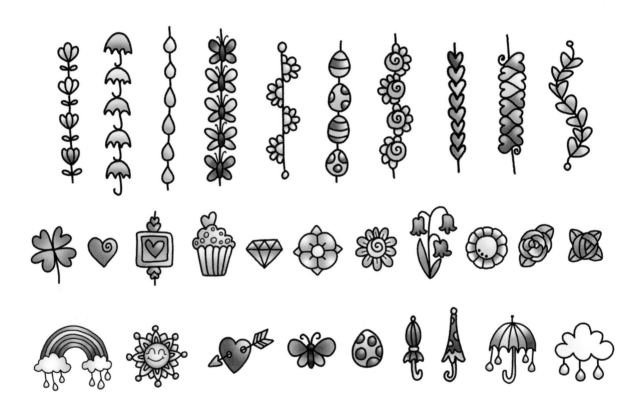

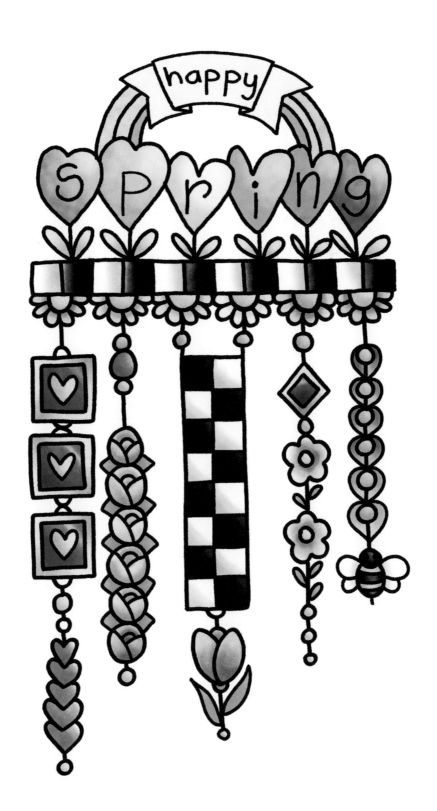

1. Start by hand lettering "March" in block letters. Add a rod underneath and two circles on each end.

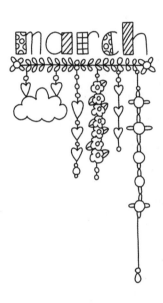

2. Add fun patterns to each letter. Add leaves to the rod, and turn the rod ends into flowers. Then start sketching some dangles below it. Notice how the cloud connects two dangles into one larger one.

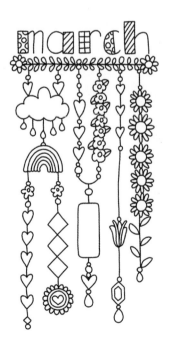

3. Add the outlines of more charms in order to lengthen the dangles.

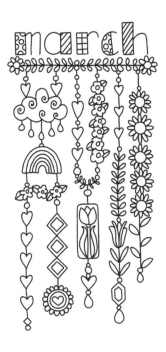

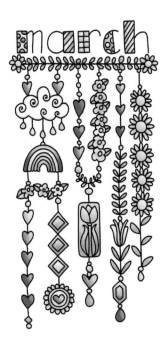

4. Add finishing touches to your dangles and charms.

5. Add color. This pastel rainbow color palette definitely says "spring"!

NOW IT'S YOUR TURN!

1. Pencil in a circle to use as a guide for a wreath, and draw groups of small flowers around it. Hand letter "April" in the center of the circle in simple cursive.

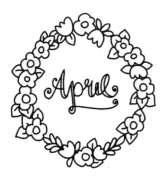

2. Add leaves to the wreath to fill it out. Draw a second line on each downstroke of the letters in April, to create "faux calligraphy."

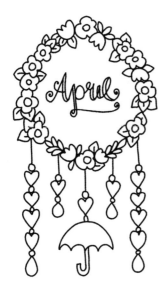

3. Begin sketching in the outlines for five dangles.

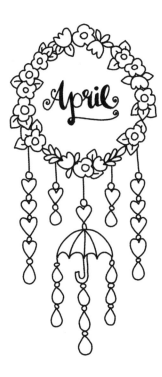

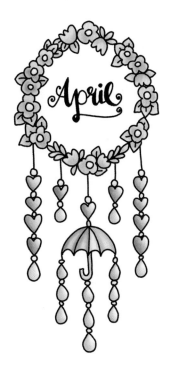

4. Add more charms to the dangles and add detail to the umbrella charm. Then fill in outlines of the letters of April.

5. Add color.

NOW IT'S YOUR TURN!

1. Write "April Showers" in a fun, curly font. Draw a fluffy cloud around it. Then add some clouds behind the first one.

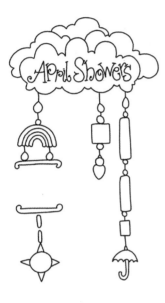

2. Start sketching in a few dangles below the clouds.

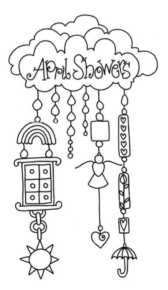

3. Add more dangles, charms, and details.

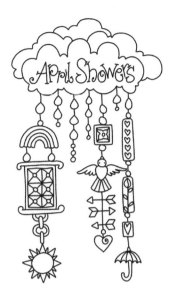

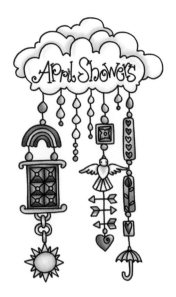

4. Add the finishing touches to the design.

5. Add color.

 NOW IT'S YOUR TURN!

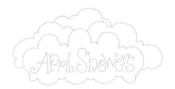

1. Hand letter "Happy Easter" and draw a simple rectangular frame around it. Then attach some beads above and below the frame. Connect the beads on top with a squiggly line, and draw another squiggly line above that.

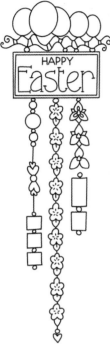

2. Connect the two squiggly lines with some short rods and begin sketching in some Easter eggs above that. Also, begin sketching in three dangles below the frame.

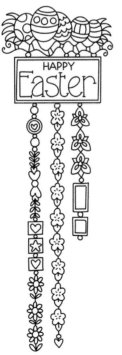

3. Add patterns to the Easter eggs and some strands of grass on either side of them. Add more charms and details to the dangles.

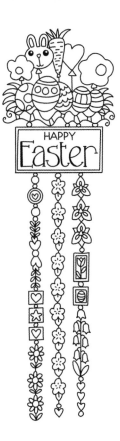

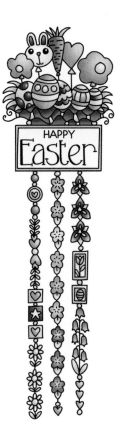

4. Attach several balloons behind the eggs, including one in the shape of a carrot and another with bunny ears. Add finishing touches to the dangles.

5. Add color.

 NOW IT'S YOUR TURN!

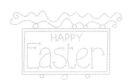

1. Hand letter "May" and draw a simple box around it.

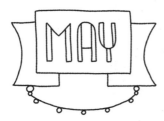

2. Turn the box into a ribbon banner. Hang a curved rod to the banner, along with beads to act as anchor points for dangles.

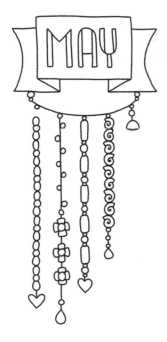

3. Begin drawing the dangles.

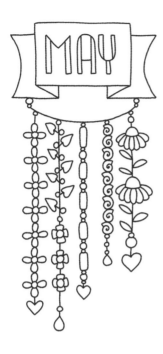

4. Complete your dangles with more charms and details.

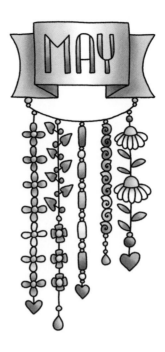

5. Add color.

NOW IT'S YOUR TURN!

1. Hand letter "Happy Birthday," adding rods to create a semicircular design.

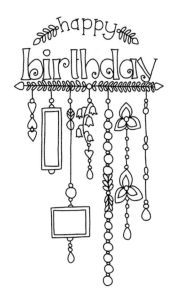

2. Add leaves to the rods and begin sketching the dangles.

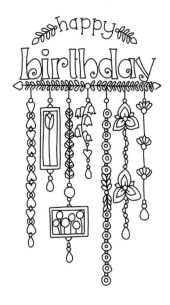

3. Add more charms and details to your dangles.

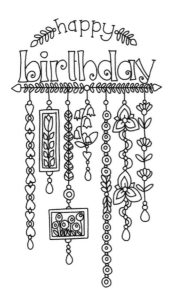

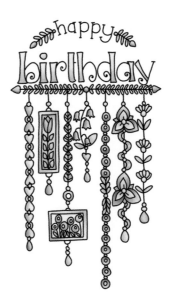

4. Add final details to your dangles and charms.

5. Add color.

NOW IT'S YOUR TURN!

1. Draw a garland of daisies.

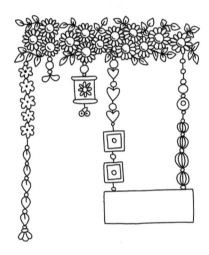

2. Add leaves to the garland and hang a few dangles below it. Hang a rectangular box between two of the dangles.

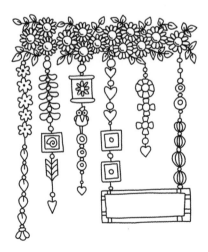

3. Add more dangles, charms, and details to your design.

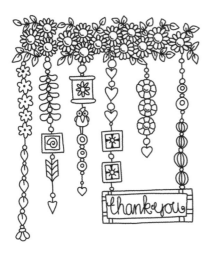

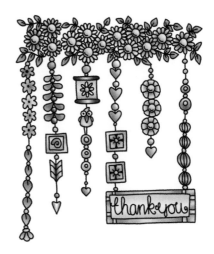

4. Hand letter "Thank You" in the framed rectangle and add finishing touches to your dangles.

5. Add color.

 NOW IT'S YOUR TURN!

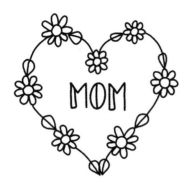

1. Hand letter "Mom" in simple block letters. Draw a heart around it in pencil, adding some daisy flowers and leaves on it.

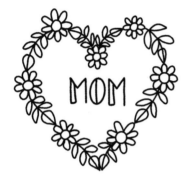

2. Add more leaves to fill out the wreath.

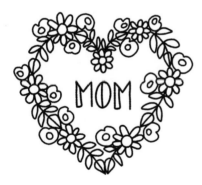

3. Add some small flowers around the wreath.

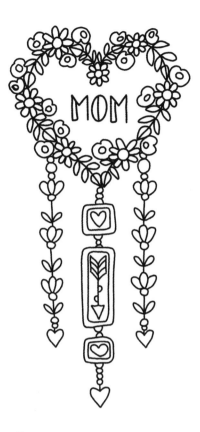

4. Attach a trio of dangles to the bottom of the wreath.

5. Add color.

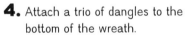

NOW IT'S YOUR TURN!

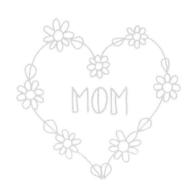

Summer

Brightly colored flowers, butterflies, bees, golden wheat fields, sunshine, beaches, waves, ice cream, chilled fruit, and drinks all come to mind when I think of summer. The following summer-inspired designs incorporate these themes, while featuring warm, tropical, and bright color palettes. Below are a few summery designs for dangles and charms:

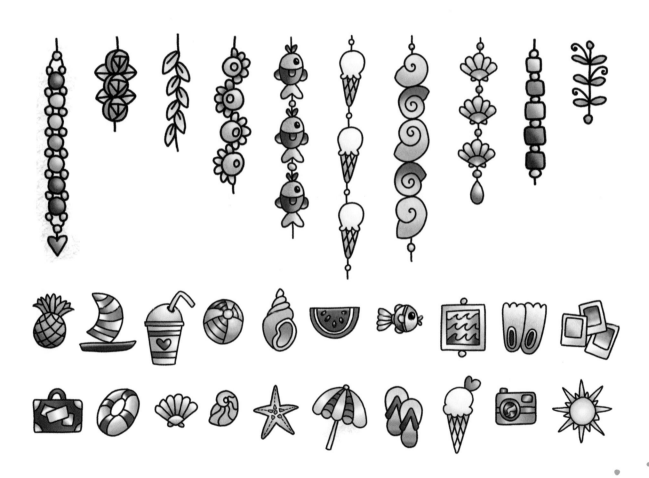

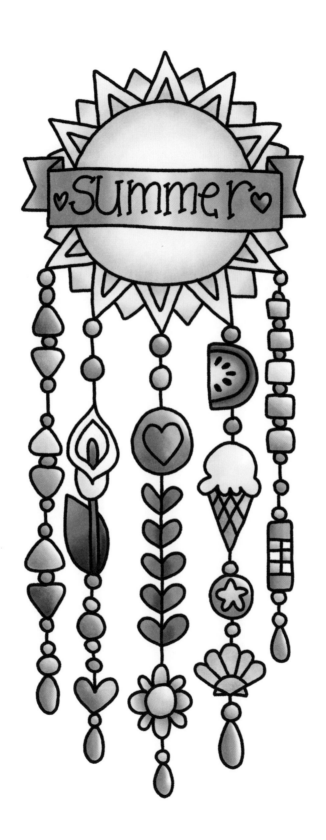

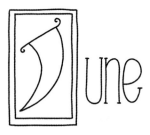

1. Draw a block letter "J" with a box around it. Then draw the remaining letters of "June" outside the box.

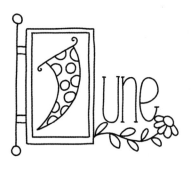

2. Add circles inside the "J." Then attach a decorative rod to the left side of the box and a curvy flower stalk to the right of the box, underneath the letters.

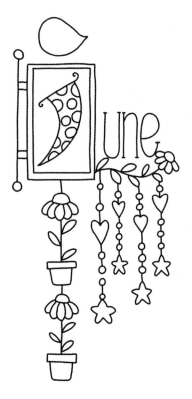

3. Attach a large dangle underneath the box, and then attach smaller ones to the flower stalk. Begin sketching a bird on top of the box.

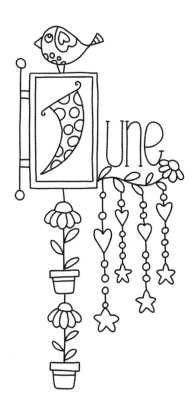

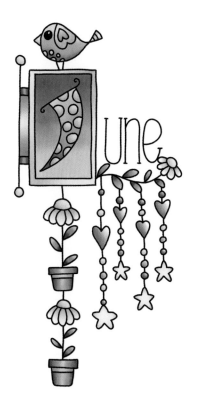

4. Finish drawing the bird and add the final details to the charms.

5. Add color.

 NOW IT'S YOUR TURN!

1. Write "July" in cursive, with the loops on the J and Y forming spirals. Add a bead at each end of the word.

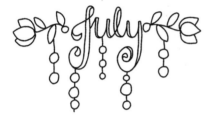

2. Thicken the downstrokes of the letters and attach flower vines to the beads. Draw the beginnings of five dangles below.

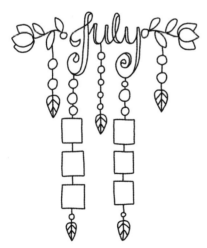

3. Lengthen the dangles with more charms.

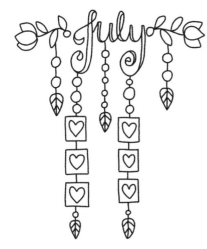

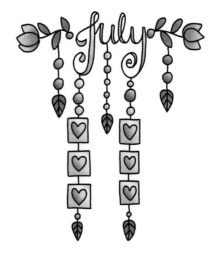

4. Add finishing touches to your charms.

5. Add color.

NOW IT'S YOUR TURN!

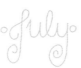

1. Hand letter "August" and draw a box around it.

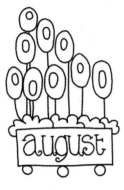

2. Draw some cloud-shaped foliage on top of the box, and then add oval-shaped flowers with stems. Finally, attach beads to the bottom of the box.

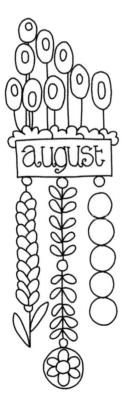

3. Attach dangles to the beads.

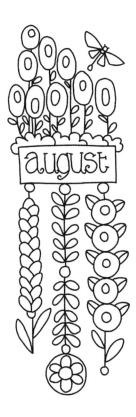

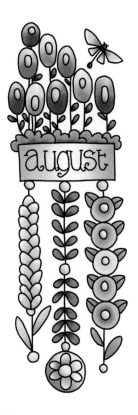

4. Add finishing touches to your charms. Then draw leaves on the flowers above the box. Finally, draw a dragonfly above the flowers.

5. Add color!

NOW IT'S YOUR TURN!

1. Hand letter "Congratulations" and add a simple frame around it. Sketch the beginnings of a grape hyacinth flower below it.

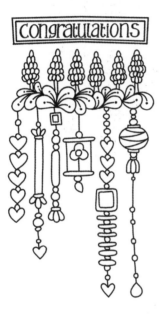

2. Draw in the rest of a row of six grape hyacinths. As you add more hyacinths to the row, sketch out dangles beneath them.

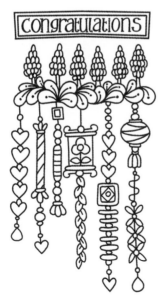

3. Add finishing touches to your dangles.

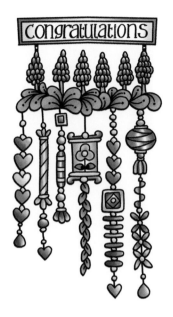

4. Attach the grape hyacinth row to the rectangular box above it and add color.

 NOW IT'S YOUR TURN!

Celebrate

1. Hand letter "Celebrate" and draw a box around it.

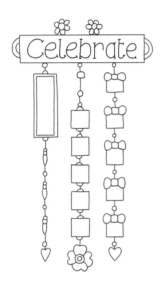

2. Draw two flowers above the box and one handle on each side of it. Then sketch out your dangle designs.

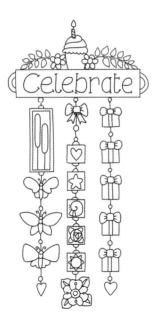

3. Add charms and details to your dangles. Also draw a cupcake above the box, adding leafy vines to the flowers on either side of it.

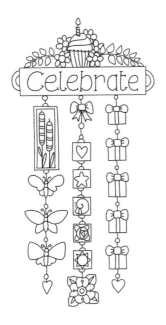

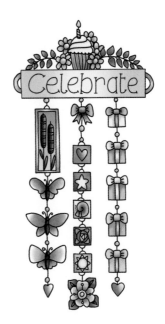

4. Add more flowers around the cupcake.

5. Color.

NOW IT'S YOUR TURN!

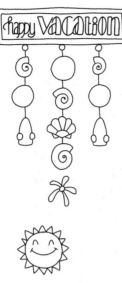

1. Hand letter "Happy Vacation" and draw a basic frame around it. Begin sketching out three dangles attached to the bottom of it.

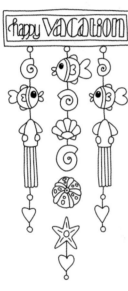

2. Draw a smiling sun above the framed message. Add more aquatic-themed charms to your dangles.

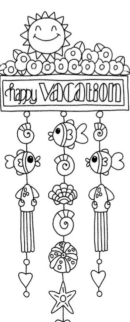

3. Fill the space between the sun and framed message with little flowers. Then add finishing touches to your charms.

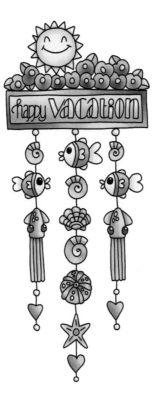

4. Color! Bright, tropical colors are very fitting for this coral reef-inspired design.

NOW IT'S YOUR TURN!

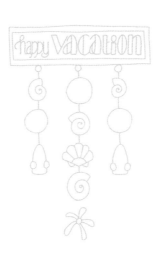

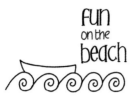

1. Hand letter "Fun on the Beach." Below it, draw a series of spirals that form waves, with a simple boat floating on top.

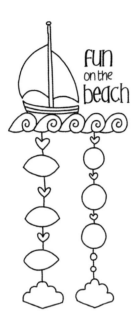

2. Turn your simple boat into a sailboat with a mast and sails. Connect the bottoms of each wave to one another and add two simple dangles below.

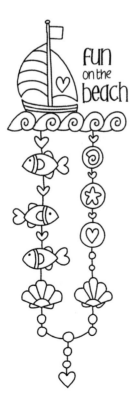

3. Fill in the details of your charms and sailboat. Then connect the two dangles together with a string of pearls, ending the dangle with a heart-shaped charm.

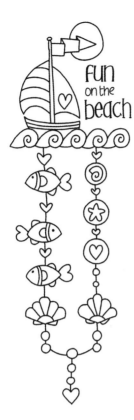

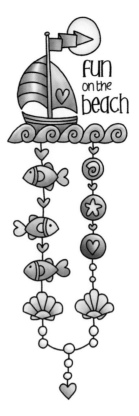

4. Attach a flag to the top of the mast, dividing it into three sections, so that it appears to be flapping in the wind. Draw a sun behind it.

5. Add color. Tropical seas have inspired the color scheme here.

 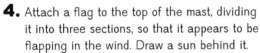 NOW IT'S YOUR TURN!

1. Write "Summer," making the spirals in the "S" into whimsical spirals. Pencil in a circle around it, along with little circles where you would like to place flowers. Finally, draw a heart and simple flourishes underneath the word.

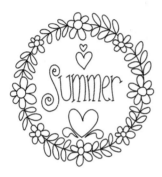

2. Ink in the flowers and connect them using the pencil circle as a guide. Erase the pencil lines and add leaves between the flowers. Finally, add a couple of hearts above "Summer."

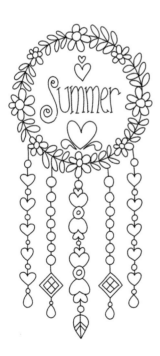

3. Hang five dangles from the wreath. Notice how the dangles form a gentle curve at their ends, mirroring the curve of the wreath.

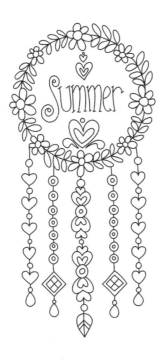

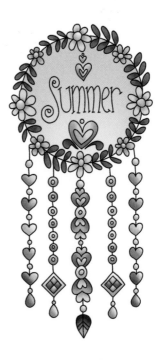

4. Add details to your dangles, as well as the hearts above and below the lettering.

5. Add color.

NOW IT'S YOUR TURN!

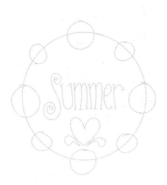

Autumn

In autumn, the leaves change color and fall, revealing the underlying architecture of nature. Fruits, berries, and nuts are harvested, and wild mushrooms grow in abundance. During this season of harvest, Halloween, and Thanksgiving, the days grow shorter and the nights, cooler.

The dangle designs for this time of year feature rich, warm colors like amber, brown, gold, and purple. Autumn-themed charms include acorns, apples, toadstools, and pumpkins, as well as creepy cats, ghouls, spiders, and moons.

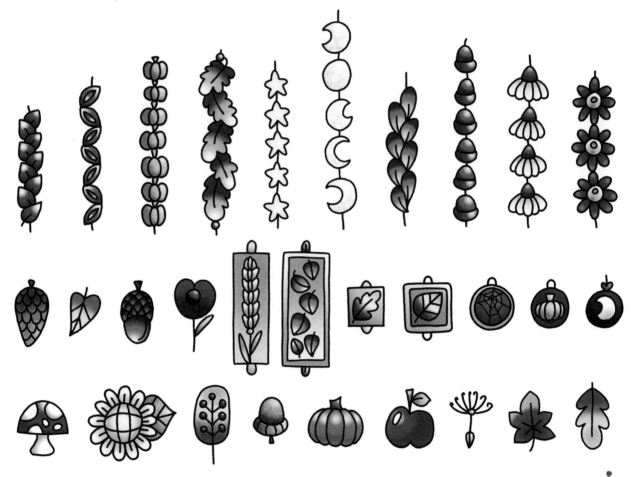

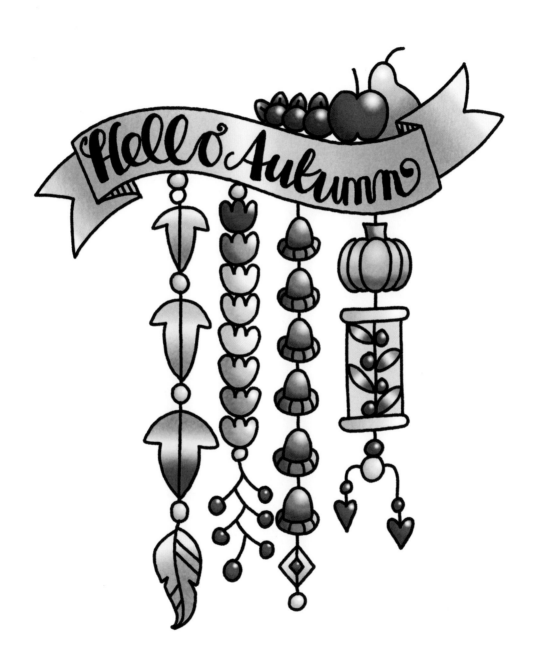

1. Write "September" in capital letters. Then draw a ribbon frame around it and begin sketching in five dangles.

2. Thicken the lettering and add more details to your charms and dangles.

3. Fill in the lettering and add finishing touches to your dangles. Draw three acorns on top of the banner and add leaves and flourishes on either side. Add height to the design by adding sprigs of berries above the acorns.

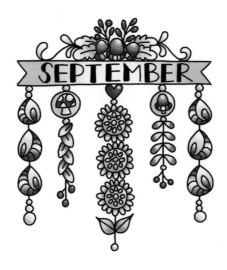

4. Color in your design. Rich, mellow, golden tones bring a very autumnal, harvest feel to this design.

NOW IT'S YOUR TURN!

1. Hand letter "October" and draw a box around it.

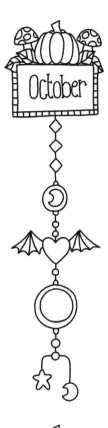

2. Draw a pumpkin atop the box, followed by leaves and toadstools on either side. Then add a simple border around the sides and bottom of the box. Finally, draw a dangle below.

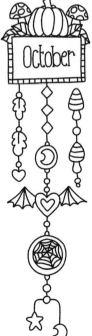

3. Draw dangles on both sides of the central dangle and add details to the charms.

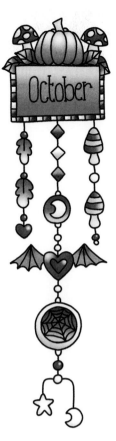

4. Connect everything together and color in your design. Shades of purple, orange, and black are a nod to Halloween.

 NOW IT'S YOUR TURN!

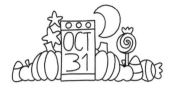

1. Draw a rectangle in the style of a calendar page and add the date "Oct 31" inside. Then add pumpkins, apples, and candy on both sides of it. Finally, draw stars and a crescent moon above it.

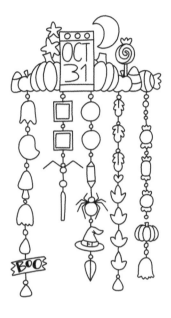

2. Begin sketching in five dangles.

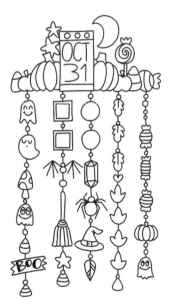

3. Add more details to your dangles and charms.

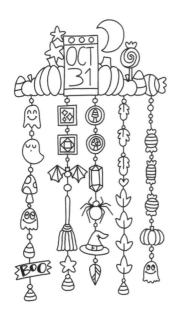

4. Add finishing touches.

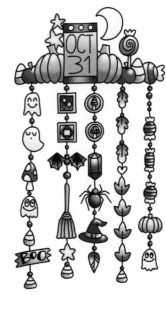

5. Color.

NOW IT'S YOUR TURN!

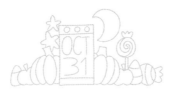

1. Write "November" in a whimsical style with lots of spirals. Then draw a box around it and a stick-like bar or "shelf" under it.

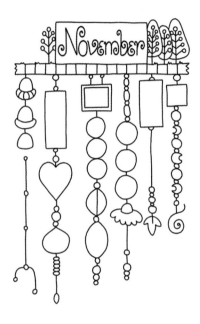

2. Begin sketching trees on either side of the box and add a simple pattern to the bar below it. Then add the outlines of six dangles.

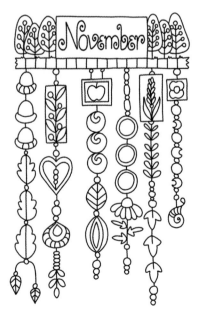

3. Complete the trees, and then add further details to the dangles.

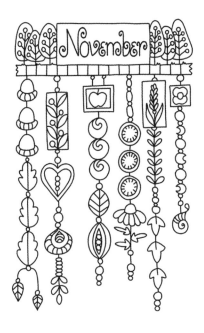

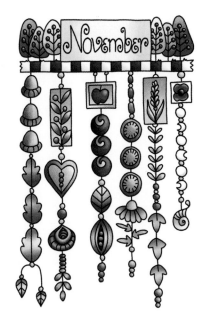

4. Add finishing touches to the charms.

5. Color.

 NOW IT'S YOUR TURN!

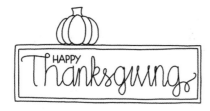

1. Start by lettering "Thanksgiving" in cursive, and then add "Happy" in small capitals above it. Draw a simple frame around the greeting and draw a pumpkin on top of it. Draw a double box around the lettering and add a pumpkin on the upper left side.

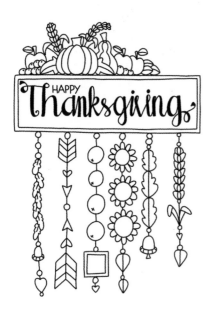

2. Thicken the downstrokes on the cursive lettering. Add harvest fruits and wheat to the top of the design. Then attach six dangles to the bottom of the frame.

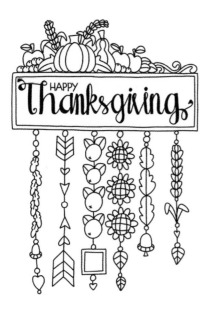

3. Add more details to the charms and an organic flourish on top of the right side of the frame.

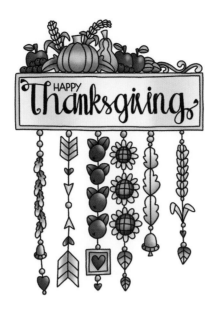

4. Draw a heart inside the square charm and color it all in!

NOW IT'S YOUR TURN!

1. Hand letter "Fall Leaves" in a bouncy, cursive script. Then draw a leafy border around it.

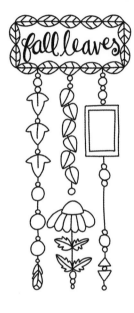

2. Thicken the downstrokes of the lettering and attach three dangles to the bottom of the leafy frame.

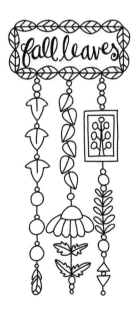

3. Add finishing touches to the charms.

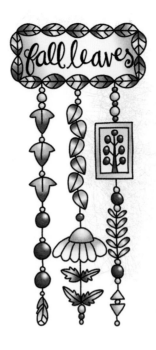

4. Color.

NOW IT'S YOUR TURN!

1. Draw a branch with leaves attached.

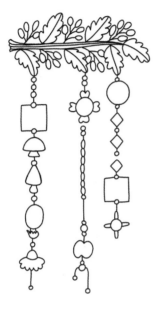

2. Add sprigs of berries to the branch. Then attach dangles to three of the lower leaves.

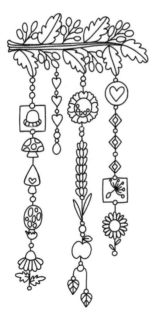

3. Fill in the details of your charms and hang an additional dangle from one of the berries.

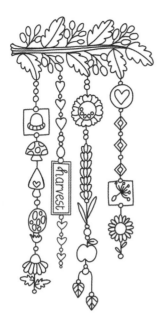
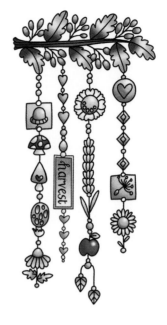

4. Add a rectangular charm to the fourth
dangle, with heart-shaped beads below it.
Hand letter "Harvest" inside the rectangle.

5. Color.

NOW IT'S YOUR TURN!

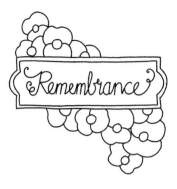

1. Hand letter "Remembrance" in cursive and draw a vintage-style frame around it. Start drawing poppies on the upper left and lower right areas of the design.

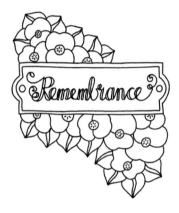

2. Thicken the downstrokes on the cursive lettering. Add details to the centers of the poppies, and then draw leaves around the edges.

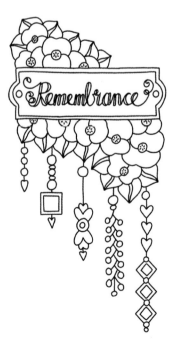

3. Anchor dangles to the leaves, lining up their ends in a near-perfect diagonal.

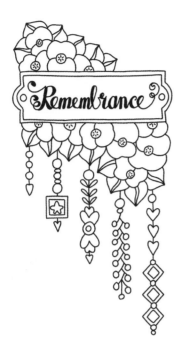

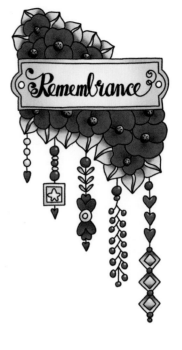

4. Add further details to the charms.

5. Add color.

NOW IT'S YOUR TURN!

Dangle Directory

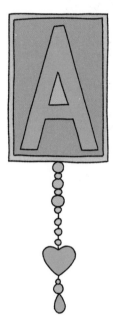

Page 14

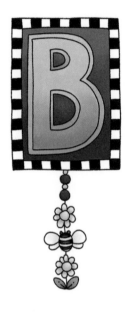

Page 15

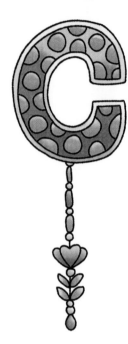

Page 16

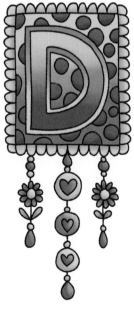

Page 17

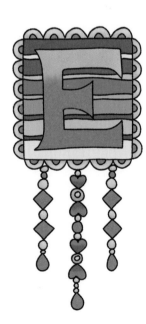

Page 18

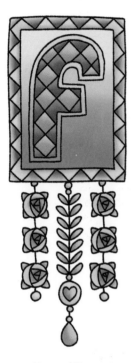

Page 19

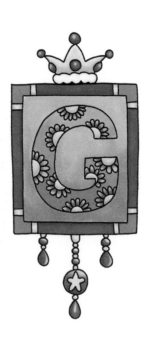

Page 20

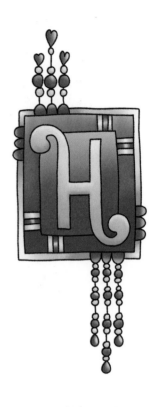

Page 21

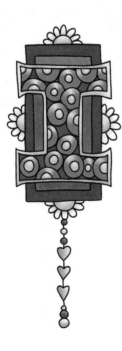

Page 22

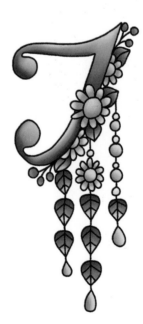

Page 23

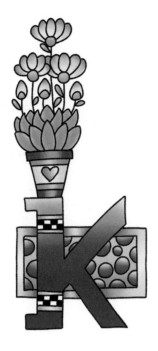

Page 24

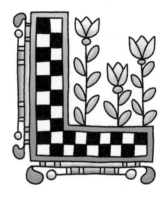

Page 25

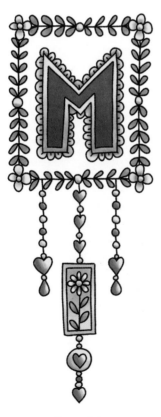

Page 26

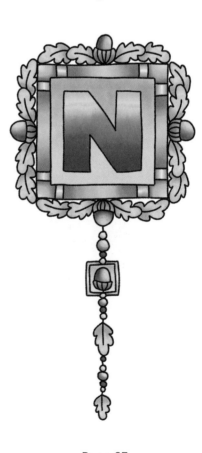

Page 27

Page 28

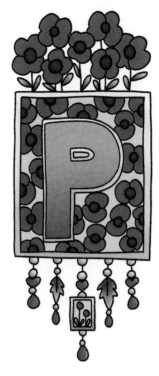

Page 29

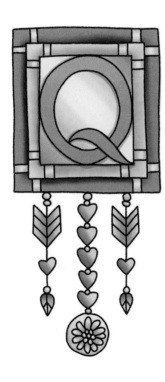

Page 30

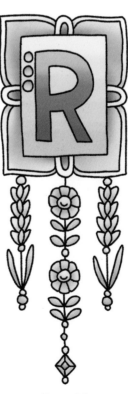

Page 31

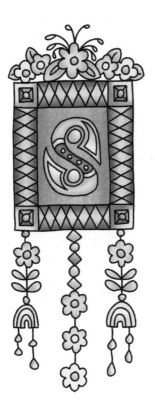

Page 32

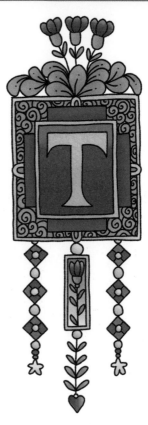

Page 33

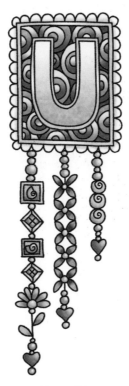

Page 34

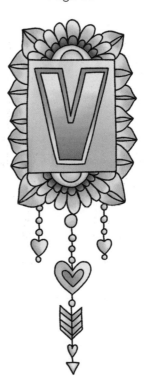

Page 35

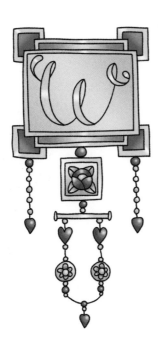

Page 36

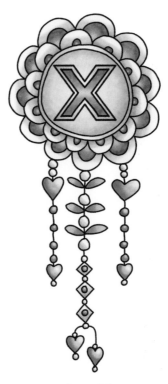

Page 37

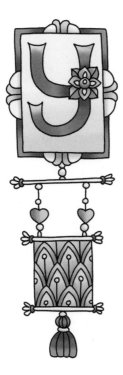

Page 38

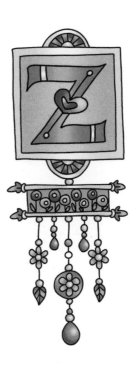

Page 39

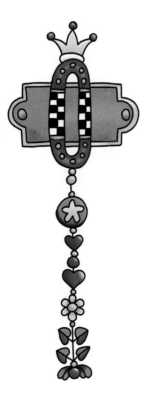

Page 40

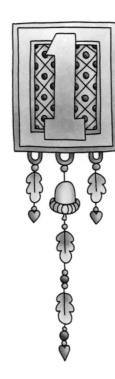

Page 41

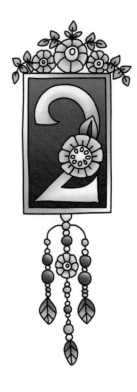

Page 42

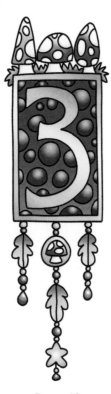

Page 43

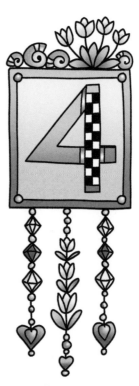

Page 44

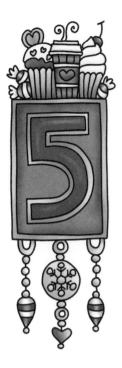

Page 45

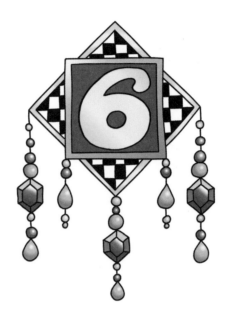

Page 46

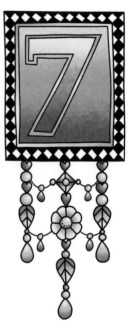

Page 47

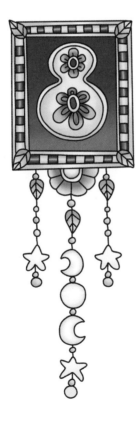

Page 48

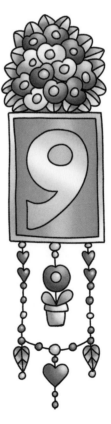

Page 49

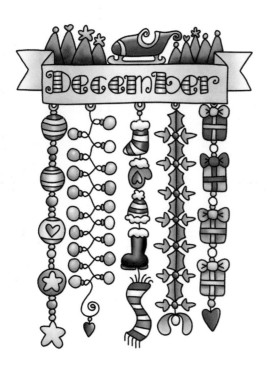

Page 58

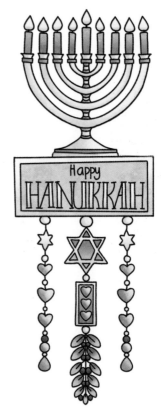

Page 60

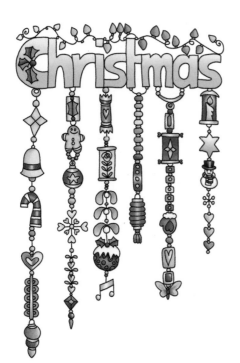

Page 62

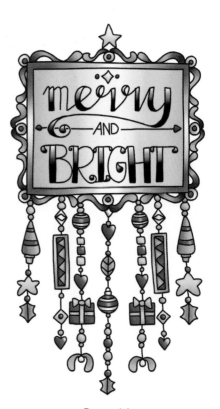

Page 64

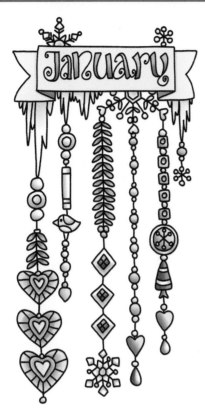

Page 66

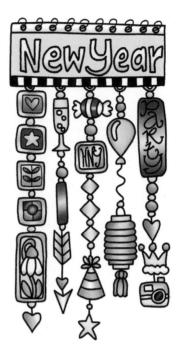

Page 68

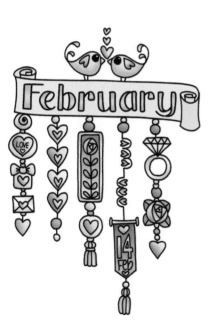

Page 70

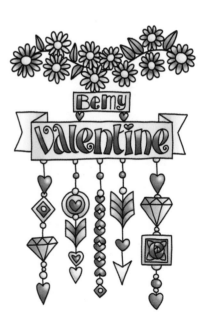

Page 72

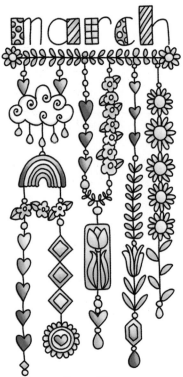
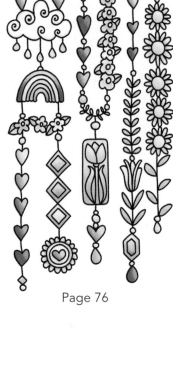

Page 76

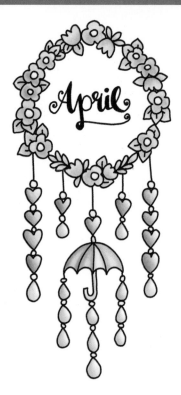

Page 78

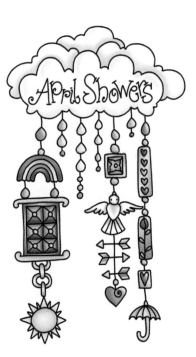

Page 80

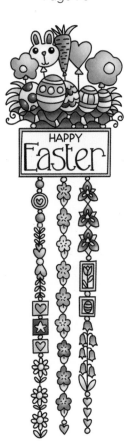

Page 82

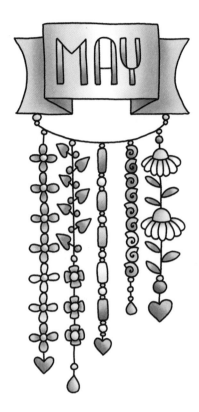

Page 84

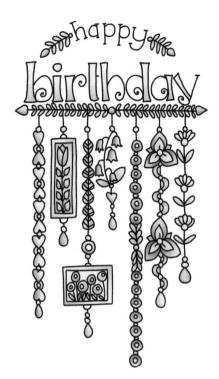

Page 86

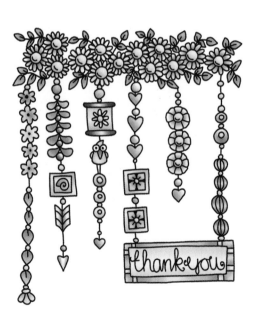

Page 88

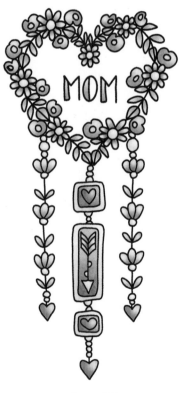

Page 90

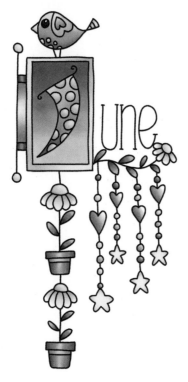

Page 94

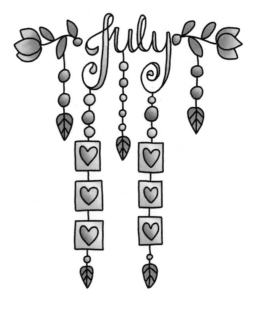

Page 96

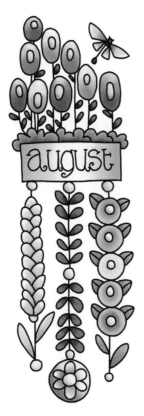

Page 98

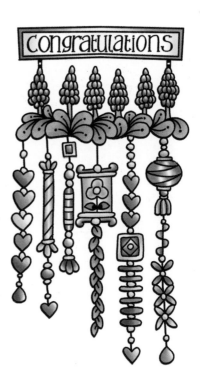

Page 100

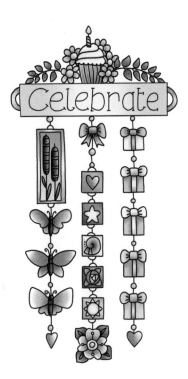

Page 102

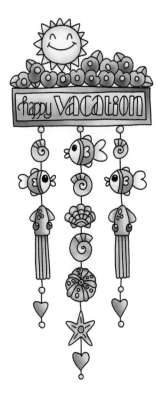

Page 104

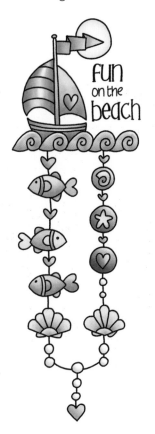

Page 106

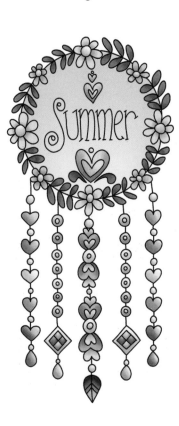

Page 108

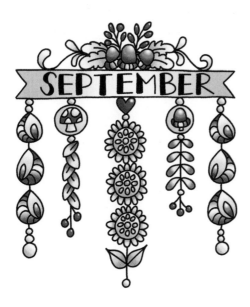

Page 112

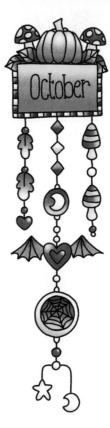

Page 114

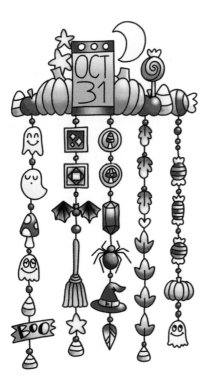

Page 116

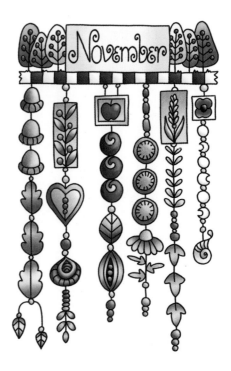

Page 118

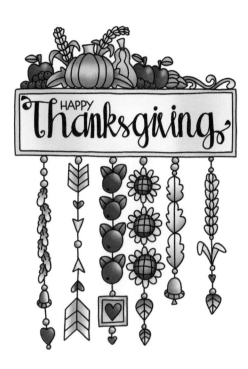

Page 120

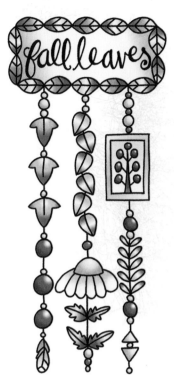

Page 122

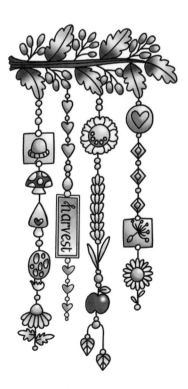

Page 124

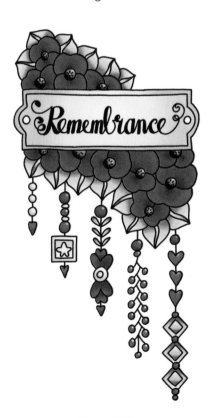

Page 126

About the Author

Angela is a self-taught artist who finds inspiration in the world around her, including architecture—particularly Romanesque and Gothic—Anglo-Saxon, Celtic, and Medieval illuminated manuscripts; flowers, leaves, capsules, pods, seeds and other natural forms; fossils and minerals; and microscopic photographs. Much of her work is abstract and intricate in detail, with flowing lines and often there is a whimsical element to Angela's artwork. Angela likes to use both fine-drawing and water-soluble pens, alcohol markers, and inks in traditional media, with a liberal sprinkling of metallic and iridescent highlights when the work is not for reproduction. She also works digitally, but uses digital platforms in much the same way as she would with traditional media. She is the illustrator for the successful *Color Me* series of books written by Lacy Mucklow, and she has many adult-coloring books to her name. When not indulging in art, Angela likes to read, walk, cook, knit, play the flute, and visit historic places (which usually results in tea and cake being enjoyed, too!). She lives in a small home in South Wales, UK.

Acknowledgments

Jeannine, thank you for believing in me, encouraging me, and giving me opportunities to share my art with others, starting with *Color Me Calm*.

Melanie, thank you for your skills at organizing this scatty, hare-brained artist as well as your lovely words of encouragement.

John, for helping to bring *A Dangle a Day* into being, and to all at Quarto who've helped to make *A Dangle a Day* a reality.

Last, but not least, my thanks go to all who have supported and encouraged me as I continue on this artistic and creative adventure, particularly Kevin, Lauren, Steve, and Brett.